D0272610

ART NOUVEAU

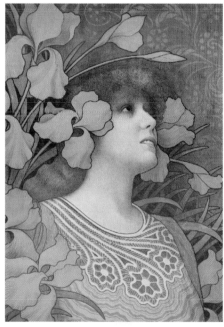

GORDON KERR

PULTENEY
PRESS

CONTENTS

Contents

INTRODUCTION

A RT NOUVEAU was the first great international style, practiced by a diverse range of artists, working in a variety of disciplines – art, architecture and the applied arts – in numerous countries. Its heyday was around the end of the nineteenth century and the beginning of the twentieth – from about 1890 to 1905 – and its explosion of organic motifs, expressed in highly stylized curvilinear forms, reverberated throughout Europe, with practitioners in cities as diverse as Moscow, Glasgow, Brussels, Vienna and Barcelona.

This new modern style broke entirely with the art of the past, dispensing with the representation of classical and mythological themes and the belief that these were the only subjects worthy of artistic representation. Importantly, however, it also broke down the barriers that existed between the applied and the fine arts. Many of the style's practitioners multi-tasked, switching from jewellery design to architecture to furniture design with apparent ease, each time carrying the values of the new style with them.

Art Nouveau could be said to be an attitude, or a way of thinking about modern society and of utilising the most modern of production techniques. It also represented a new kind of all-encompassing art, an art that was all around us in everyday things; in fact, it made people reconsider the everyday and ask why we could not have art and beauty in ordinary objects, too. Thus, disciplines other than painting began to be considered a suitable way of expressing the new style. The Art Nouveau style could be found in architecture, furniture, glassware, graphic design, jewellery, pottery, metalwork, in textiles and sculpture. Even advertising became a vehicle for this new artistic tendency and advertising posters became works of art, embodying the Art Nouveau style.

It was what could be described as a total style, embracing every field of design. You could, if you wanted to, have lived in an Art Nouveau house, slept in an Art Nouveau bed and relaxed on Art Nouveau furniture, dined using Art Nouveau cutlery and crockery, read by an Art Nouveau light and have donned Art Nouveau jewellery and

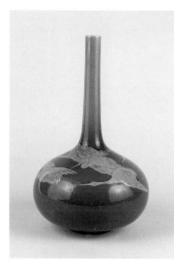

ROCKWOOD POTTERY VASE
Clay, by Artus van Briggle, 1896.
Museum of Fine Arts, Houston,
Texas, USA.

textiles when you went out to dine at an Art Nouveau designed restaurant.

What also makes Art Nouveau fairly unique amongst art movements is that it enjoyed a different expression in each place in which it flowered. The people of France, for instance, enjoyed Hector Guimard's extravagant glass and ironwork designs for the Paris Metro, but its true flowering was in the applied arts where René Lalique's delicately beautiful glassware and the sinuous designs of Emile Gallé's furniture and ceramics gave real expression to the new style. The artist, James Ensor, and architects such as Victor Horta and Henry Van de Velde gave vent to the style in Belgium and, in Spain, Antoni Gaudi created flowing, sinuous buildings that seemed to have arrived in the centre of Barcelona from another planet. His Art Nouveau/Gothic Revivalist masterpiece, La Sagrada Familia, is a monument to his genius, even in its perpetually unfinished state.

In Germany, *Jugenstil* drew its precise, hard edges from traditional German print-making, differentiating it from the more common organic style of the time. But it remains quirkily of its style, especially in the field of typography by which magazines such as *Simplicissimus* and *Pan* trumpeted the *Jugendstil* look to the world. The artists of the Viennese Secession, such as Gustave Klimt in his 1901 painting *Judith and the Head of Holofernes*, embodied the modern look and even in America, European ideas infiltrated the designs of the more adventurous architects, such as Frank Lloyd Wright and Louis Sullivan.

Companies like Tiffany and Liberty & Co. brought a commercial aspect to Art Nouveau as for the first time, art became accessible to all. Liberty & Co. sold Oriental ceramics and textiles in the 1870s and produced a range of work by Archibald Knox, a Manx designer with Scottish origins. Knox became famous through his work for Liberty's and it included items both decorative and functional – silver and pewter tea sets, inkwells, boxes, jewellery and even gravestones. In fact, he designed the gravestone of Arthur Lasenby Liberty, the founder of the store.

The first mention of the term 'Art Nouveau' came in Belgium in the 1880s when the Belgian journal *L'Art Moderne* used it to describe the work of a group of progressive Belgian artists working under the group name of Les Vingt – 20 artists trying to blow apart the prevailing conventions and create a new style. Like

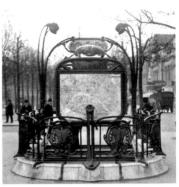

STATION DE METRO ANVERS. ANVERS STATION, PARIS, FRANCE
Designed by Hector Guimard, 1909.

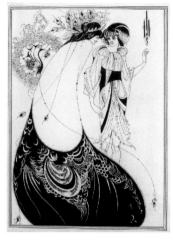

THE PEACOCK SKIRT,
Illustration for the English edition of Salome, by Oscar Wilde.
Black ink and graphite on paper, by Aubrey Beardsley, 1894. Fogg Art Museum, Harvard University Art Museum, USA.

many artists in Europe and America, they were soaking up the writings of French Gothic Revival architect, Eugene-Emmanuel Viollet-le-Duc and the influential British art critic, John Ruskin, who advocated a holistic approach to the arts, destroying the barriers that had traditionally existed between each disparate artistic field.

In 1893, a new 'illustrated magazine of the fine and applied art', *The Studio*, featured, in its inaugural issue, an illustration for Irish playwright Oscar Wilde's play *Salome:* a startling work by a young English artist named Aubrey Beardsley. Its daring, sinuous line, starkly represented in striking black and white and depicting a femme fatale – said by some to be the first work of Art Nouveau – would have great influence on the style during the next few years.

Then, in a defining moment, in 1895, a shop called Art Nouveau opened its doors in Paris. It was owned by a Hamburg-born German named Siegfried Bing. and it is highly appropriate that the name of this many-tentacled movement should have come from a businessman, because Art Nouveau had a deep involvement with modern commercialism, the growth of industry and the mass-production of consumer goods. Bing had arrived in Paris

in 1854 to run his family's Oriental art business. He borrowed the description of Les Vingt to define his shop but before long, that connection had been forgotten and Art Nouveau was recognized simply as the style of the work that Bing displayed in his shop. The style championed by him was further publicised by his stand at the 1900 Exposition Universelle in Paris. The 1900 Exposition was the last, and the grandest, of a series of fairs that had been organised in Paris every 11 years since 1798. Attended by more than 50 million people during the seven months during which it was open, and incorporating the second Olympic Games, it was effectively a World Fair celebrating the achievements of the last century while looking forward to what would be achieved in the next. It was the place where escalators and talking films were first publicised and Art Nouveau was the predominant style on show. Siegfried Bing was one of the main exhibitors of the new style. He displayed collections of modern furniture, tapestries, paintings and accessories that were coordinated in both style and colour. These appeared in a set of six domestic interiors which was how he displayed his goods in his shop – designers put together interior room sets so that customers could experience the

full effect of these cutting edge, carefully coordinated items. Throughout, however, the well-deserved reputation of French craftsmanship was maintained.

Following the Exposition Universelle, there were several more important opportunities for Art Nouveau practitioners to display their wares. The Glasgow International Exhibition of 1901 featured the fabulous Russian pavilions of the most influential Russian Art Nouveau architect, Fyodor Schechtel, who had already won a silver medal at the Exposition Universelle. In 1902, the Italian city of Turin hosted the Esposizione Internazionale d'Arte Decorativa Moderna (International Exhibition of Modern Decorative Art). It was resolutely modern in its approach, stating: '*Only original products that show a decisive tendency toward aesthetic renewal of form will be admitted. Neither mere imitations of past styles nor industrial products not inspired by an artistic sense will be accepted.*' Carlo Bugatti's Art Nouveau furniture explicitly fulfilled the requirements and his work was a major feature of the exhibition.

Although Art Nouveau came to be the term used to describe the entire movement, it went by different names elsewhere. In Germany it was *Jugendstil*, derived from the magazine *Jugend: Münchner Illustrierte Wochenschrift für Kunst und Leben* (*Youth: the Illustrated weekly magazine of art and lifestyle of Munich*), founded in 1896 by German writer and publisher, Georg Hirth. The magazine promulgated the style and its name became synonymous with it. Hirsch also coined the important term 'Secession' to describe the various modern art movements around at the time. Meanwhile, in France, Art Nouveau had been known, among other things, as Le Modern Style.

In Spain, one name for it was Arte Jove (Young Art). The Casa Batlló, a building constructed in 1877, had been redesigned by local architects, Antoni Gaudi and Josep Maria Juiol, in the local Catalan form of Art Nouveau, known as Modernisme. It is a remarkable piece of work, characterised by fluid, sculpted stonework, oddly shaped oval windows and intricate tracery. There is not a straight line in sight. Like Charles Rennie Mackintosh, working at the same time in Glasgow, there is a personal element to Gaudi's work that almost separates it from the Art Nouveau movement as a whole. He seems to speak a different artistic language to other practitioners. However, like Mackintosh, he still exploits the motifs and

CABINET
Made for 14 Kingsborough Gardens, Glasgow. Painted oak, by Charles Rennie Mackintosh, 1902. Private collection/ © The Fine Art Society, London, UK.

underlying elements of the style – curvilinear forms and floral and organic forms from nature. While several of his buildings closely relate to Art Nouveau, others, principally the Sagrada Familia cathedral, also incorporate broader artistic elements such as revivalist Neo-Gothic.

The artist, Alfons Mucha, whose poster style became much beloved of hippies in the mid to late 1960s, ruled supreme in Prague. His beautiful, heavily romanticized, long-haired women, surrounded by swirling, organic or floral patterns were much prized. Numerous buildings in Prague feature elements of the Art Nouveau style – flowers and leaves entwining on facades and the figures of women curving languourously across the stonework. Examples can be found in the Hotel Pariz, the Smichov Market Hall, Hotel Central, the windows of the St. Wenceslas Chapel at St. Vitus cathedral, the city's main railway station and the Jubilee Synagogue.

In Austria, artists reacted against the establishment, represented by the Vienna Künstlerhaus in the same way that the Impressionists in Paris reacted against the reactionary approach to art displayed by the Académie des Beaux Arts in paris. Artists of what became known as the Secession, such as Gustave Klimt, Koloman Moser, Josef Hoffmann, Joseph Maria Olbrich, Max Kurzwell, and Otto Wagner eschewed the conservative view of art promulgated by the establishment and created their own style.

In Britain, the Arts and Crafts movement and the Aesthetics movement which espoused 'Art for Art's Sake', and championed non-narrative painting such as Whistler's *Nocturne*, provided a launch-pad for Art Nouveau. Arthur Mackmurdo's famous 1880 book jacket design for his essay on the churches of Sir Christopher Wren is one of a number of designs of the time that followed the new, progressive direction. Interesting wrought-iron designs and flat, floral textile patterns also showed the stirrings of the new movement.

Of course Glasgow became the centre for all British Art Nouveau design and the reason for this lay in the work of one man, Charles Rennie Mackintosh, whose design for Glasgow School of Art, both the building's exterior and its interior, as well as his Hill House in Helensburgh, represents the absolute zenith of the style, a holistic and sensuously beautiful approach to the aesthetic.

Meanwhile, Art Nouveau was even making waves in Central and Eastern Europe. The Hungarian architect, Ödön

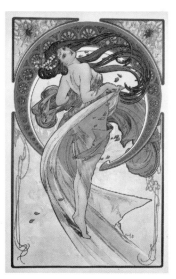

THE ARTS: DANCE
Colour litho, by Alphons Maria Mucha, 1898. The Mucha Trust.

Lechner introduced it into his work and many Art Nouveau-style buildings were built in Riga, capital of Latvia, under the umbrella of Latvian Romanticism.

In Italy, Art Nouveau manifested itself as Arte Nuova (new Art) while other names used across Europe included Stile Floreal (floral style), Lilienstil (lily style), Stile Nouille (noodle style), Stile Vermicelli (macaroni, or little worm style), Bandwurmstil (tapeworm style), Paling Stijl (eel style), and Wellenstil (wave style).

It had connections, too with places and organizations – in Paris, Hector Guimard's extravagant design for the entrances to the Paris Metro made it Le Style Métro and the London department store, Liberty & Co also defined the modern style, to many people.

Art Nouveau was an almost inevitable reaction to the stiff, reactionary approach to art adopted by the establishment of the late nineteenth century. Its artists eschewed the stultifying historicism that had blighted nineteenth century art. The French Impressionists had already smashed down a number of barriers to progress, depicting the everyday instead of relying on grand themes to make grand art and it was now the turn of the next generation to take art

even further and the dawn of a new century seemed to galvanise them.

In England, the sources for the new style can be found in the Arts and Crafts movement, led by William Morris's resolute stance against the formal rigidity of Victorian art. Alongside that were the flat perspective and vibrant colours of Japanese woodcuts that had already influenced the Impressionists. Japanese art (*Japonisme*) became accessible after trading rights were established with Japan in the 1860s. Japanese masters, such as Katsushika Hokusai, were carefully studied and aspects of their work were borrowed. Siegfried Bing and Liberty's were championing Japanese art's organic forms and typically strong designs and this was being manifested in the work of artists like James McNeil Whistler and Emile Gallé.

During the early years of the movement, one description of the Art Nouveau movement became particularly well-known. *Pan* magazine described Hermann Obrist's wall-hanging *Cyclamen* as 'sudden violent curves generated by the crack of a whip' and 'whiplash' is the term often used to describe the curves that typify Art Nouveau. They are found on buildings of the time, as well as in painting, sculpture, glasswork and ceramics.

THE THOUSAND AND ONE NIGHTS OF THE PRINCESSES AND WARRIORS
Oil and gold on canvas, by Vittorio Zecchin, 1912. Museo d'Arte Moderna, Venice, Italy.

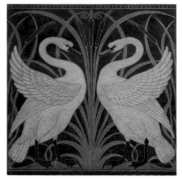

SWAN, RUSH AND IRIS WALLPAPER

Wallpaper design by Walter Crane, 1875, Victoria & Albert Museum, London, UK.

No matter the geographic spread of Art Nouveau and the individual twists that particular countries and individual artists brought to it, these whiplash curves were always present, defining the style. Details on buildings would morph curvaceously into exuberantly organic plant forms and these could be found in every other area of endeavour.

Of course, Art Nouveau did not stand alone against the established art world. It had links and overlaps with other influential movements of the time. The Pre-Raphaelites and Symbolists, for example had a great affinity with Art Nouveau, as can be seen in the work of Aubrey Beardsley, Alfons Mucha, and Edward Burne-Jones. It had its points of difference, too, however. Its characteristic look was something that Symbolism could not claim and there was a willingness amongst Art Nouveau practitioners to embrace new techniques, materials and machines to produce their work, something those involved in Arts and Crafts steadfastly would not do. Art Nouveau used new techniques and machinery to good effect, especially in working with ironwork to decorate buildings and in the machining of glass to achieve the desired sculptural effects, previously impossible.

Art Nouveau's use of natural motifs was its defining feature. There were a number of influential sources for these swirling, organic forms. German biologist, Ernst Heinrich Haeckel's 1899 book, *Kunstform der Natur* (Art Forms in Nature), *Floriated Ornament* by the Gothic Revivalist, Augustus Welby Northmore Pugin and *The Grammar of Ornament*, an 1856 book by British architect and theorist, Owen Jones, all directed artists in search of inspiration towards nature, especially if their objective was a complete break from the traditions of the past.

Thus, the sinuous, swirling line became a signature feature of the new style. However, right-angles were still permitted and were especially visible in the Art Nouveau style practiced in Scotland and in Austria. Motifs drawn from natural sources include flowers, birds, insects and the female form. These were often intertwined. Flat, decorative patterns were featured – leading to the description of it as 'Le Style Nouilles' – 'Noodle Style'. Abstract shapes and designs were also introduced and shading was used to deliberately blur three-dimensional shapes. In many cases, functionality was sacrificed for the beauty of the design.

By the end of the first decade of the twentieth century, Art Nouveau had more or less run its course. In some ways its very accessibility is what destroyed it. Its ubiquitous presence probably made people over-familiar with the style. It began to be cheapened by being applied to shoddily manufactured items, and its own practitioners and champions lost their faith in it. It was no longer at the cutting edge of art and design and by the outbreak of the First World War, the world of art was moving on to pastures new.

Art Nouveau was a shooting star of a movement, coming into existence for a comparatively short, incandescent moment. Apart from the beautiful objects and buildings it has left us with, however, it was to prove critical in the development of modern art. It brought an end to the rigidity of historic revivalism and championed function over form, marking the end of Victorian aesthetic excess. Its influence has been immense and can be seen in many Art Deco works. It has also seen a revival in its appreciation in recent years, especially during the 1960s, when a later generation challenged conventional taste as Art Nouveau had done more than half-a-century previously.

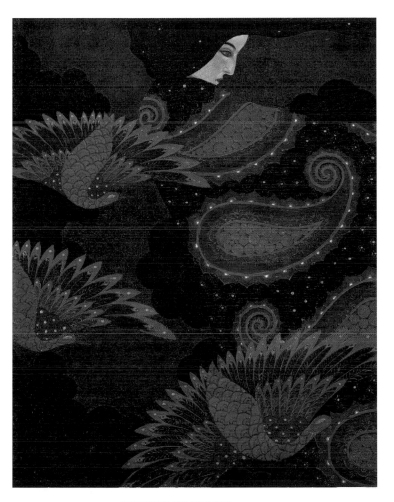

DOGESS IN BLACK
Oil on canvas, by Vittorio Zecchini, 1913. Private collection.

Plate 1

Moorish Smoking Room

*The John D. Rockefeller House, designer unknown, American school,
c. 1864-81. Brooklyn Museum of Art, New York, USA. Gift of John D. Rockefeller
and John D. Rockefeller III.*

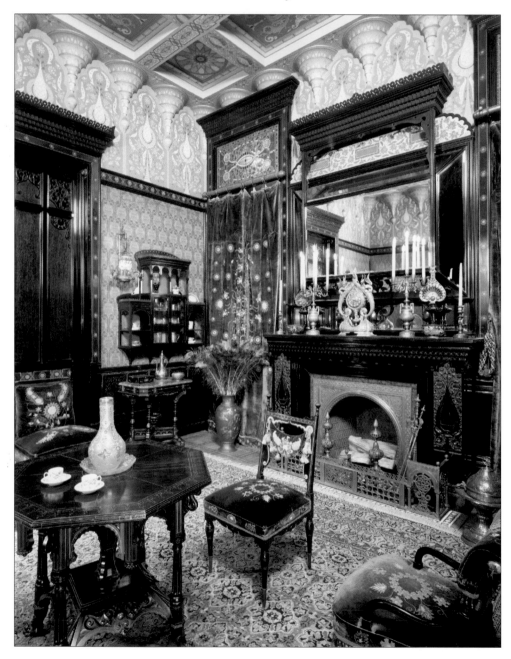

Plate 2

SWAN, RUSH AND IRIS WALLPAPER

Wallpaper design by Walter Crane, 1875,
Victoria & Albert Museum, London, UK.

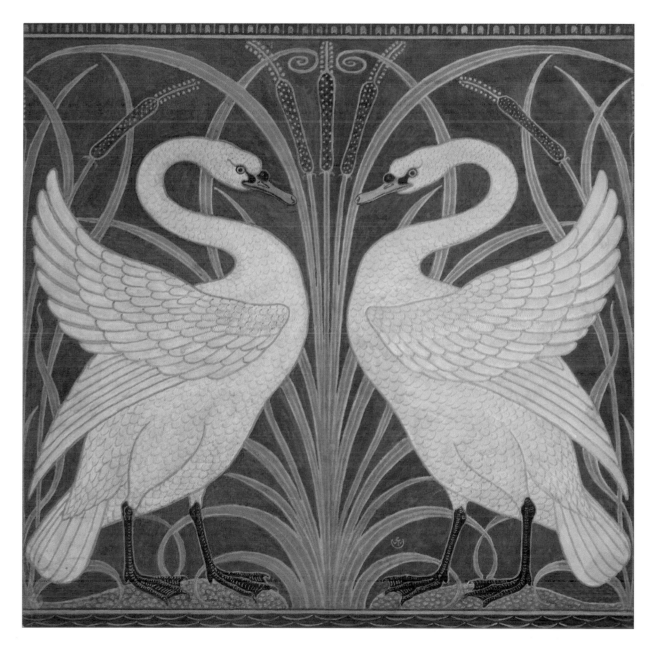

Plate 3

TABLE TOP

Wood, by Emile Galle, c. 1880. Private collection.

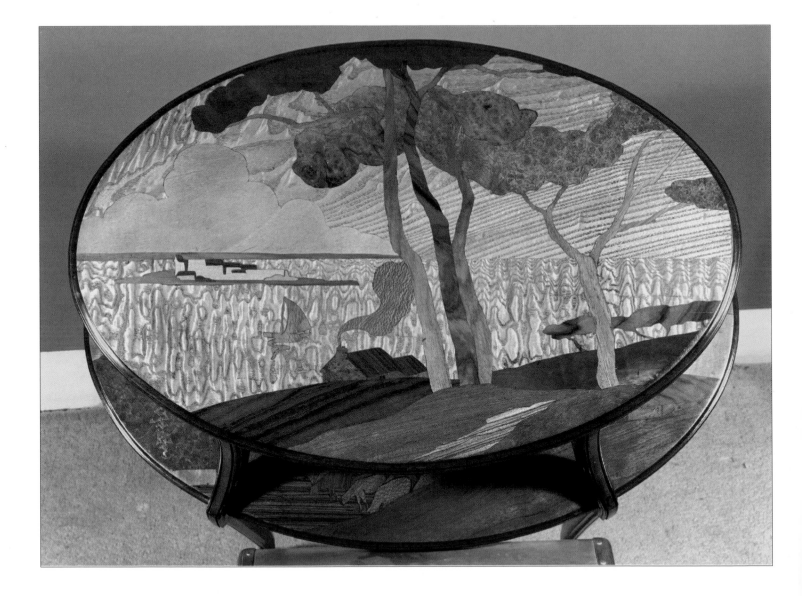

Ceramic tile, artist unknown. English school, c. 1880. Private collection.

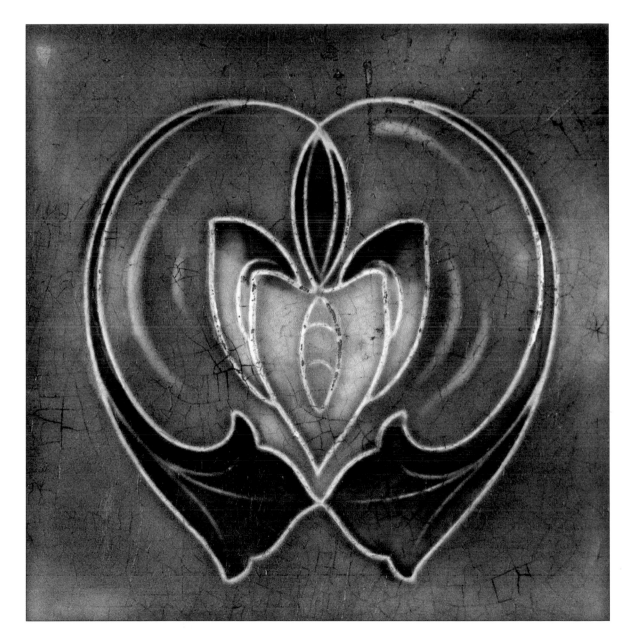

Plate 5

SAGRADA FAMILIA CATHEDRAL
by Antoni Gaudi, 1882-1926.

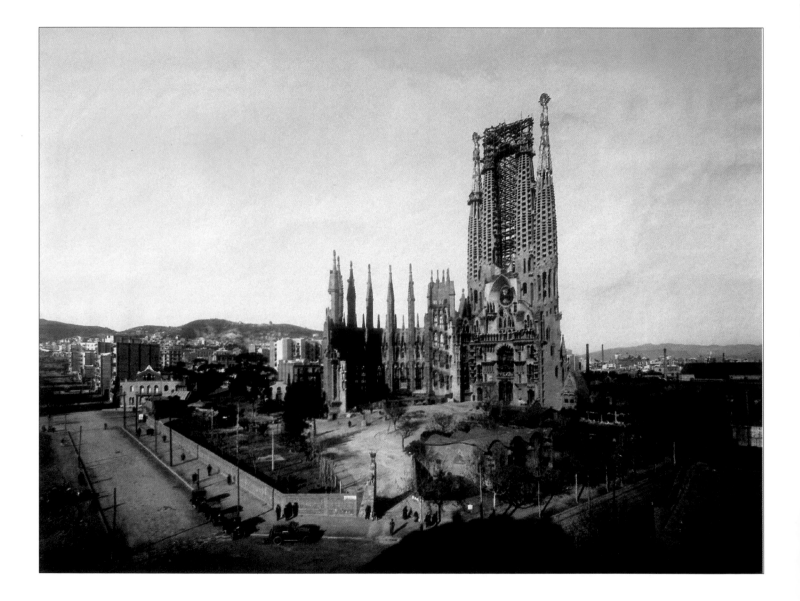

By Antoni Gaudi. 1882-1926

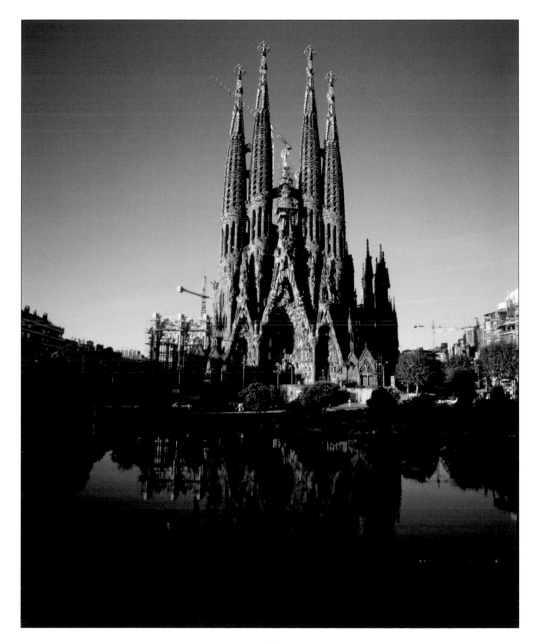

Plate 7

THE SPIRE OF SAGRADA FAMILIA

By Antoni Gaudi, 1882-1926

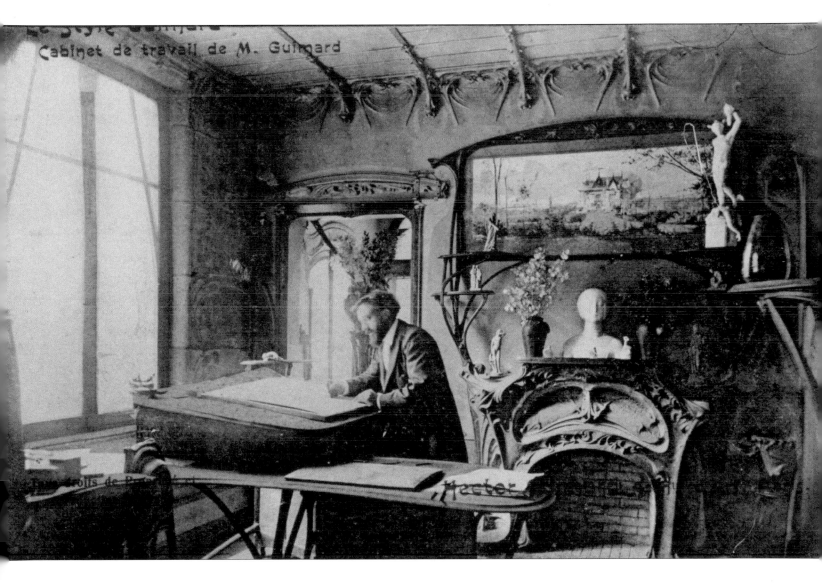

Plate 9

WOMAN FEEDING A BIRD

Oil on canvas, by George de Feure, c.1890. Private collection.
Photograph © Whitford Fine Art, London, UK.

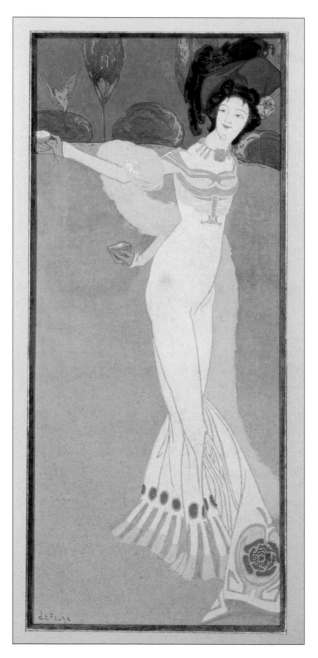

WOMAN WITH A BIRD CAGE

Plate 10

Oil on canvas, by Jozef Rippl-Ronai, 1892. Mayyar Nemzeti Galeria, Budapest, Hungary

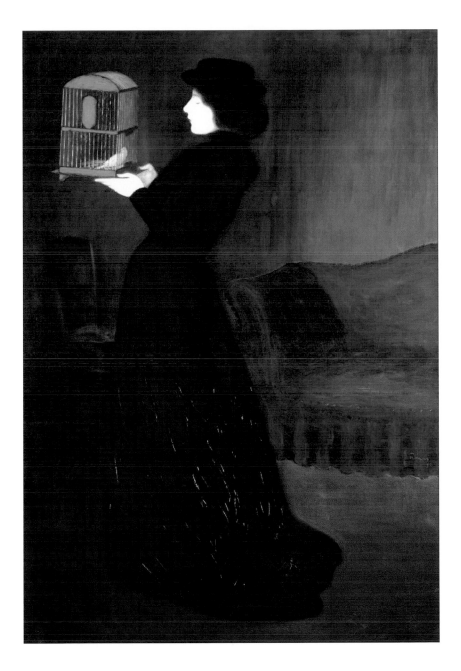

Plate II

JANE AVRIL

Litho, by Henri de Toulouse-Lautrec, 1893. San Diego Museum of Art, USA.

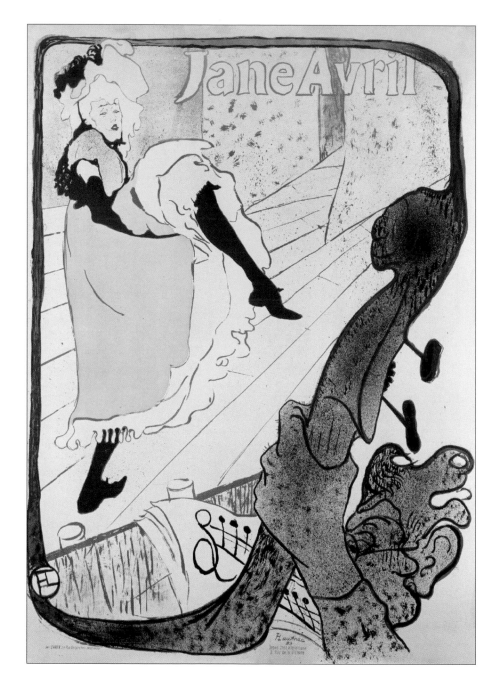

Set of six dessert doilies – Rose, Lily, Daisy, Poppy, Pink and Bluebell,
Silk damask, designed by Walter Crane, manufactured by John Wilson & sons,
1893. Private collection. The Fine Art Society & Francesca Galloway.

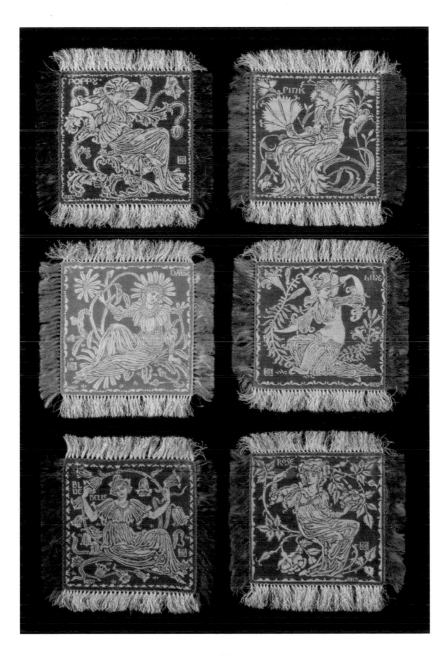

Plate 13

THE PEACOCK SKIRT

Illustration for the English edition of Salome, by Oscar Wilde.
Black ink and graphite on paper, by Aubrey Beardsley, 1894. Fogg Art Museum,
Harvard University Art Museum, USA.

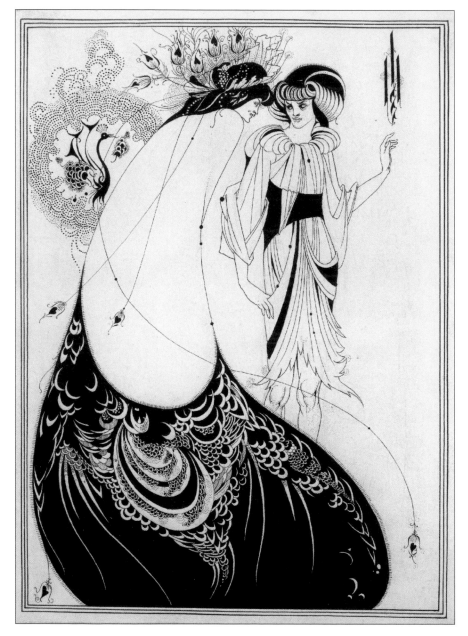

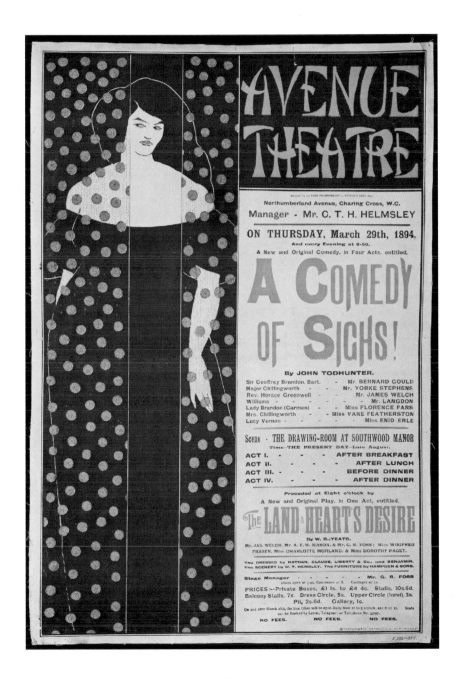

Plate 15

Two Cats

Oil on Canvas, by Theophile Alexandre Steinlen, 1894.
Pushkin Museum, Moscow, Russia.

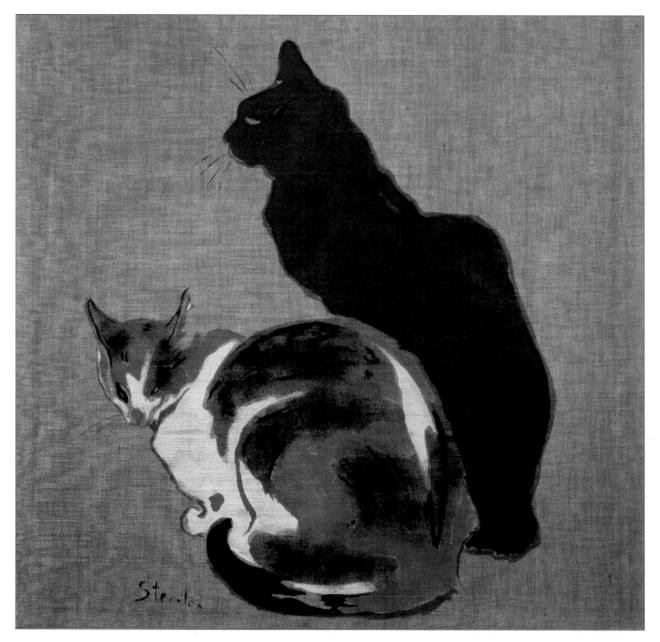

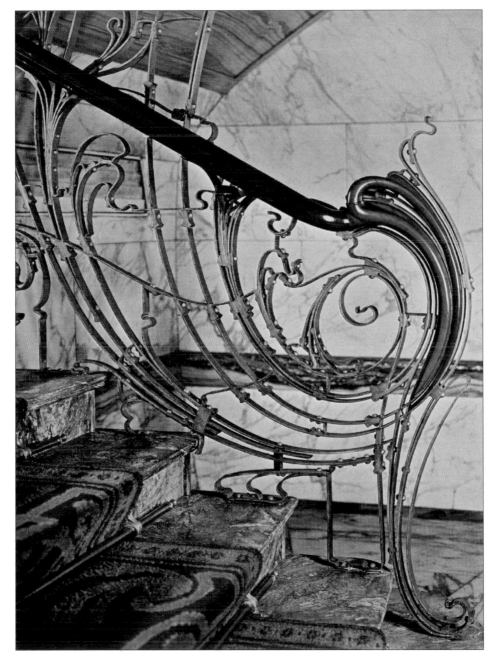

Plate 17

THE STADTBAHN PAVILION, OF THE VIENNA UNDERGROUND RAILWAY.

Coloured pencil, by Otto Wagner, c.1894-97,
Wein Museum Karlsplatz, Vienna, Austria.

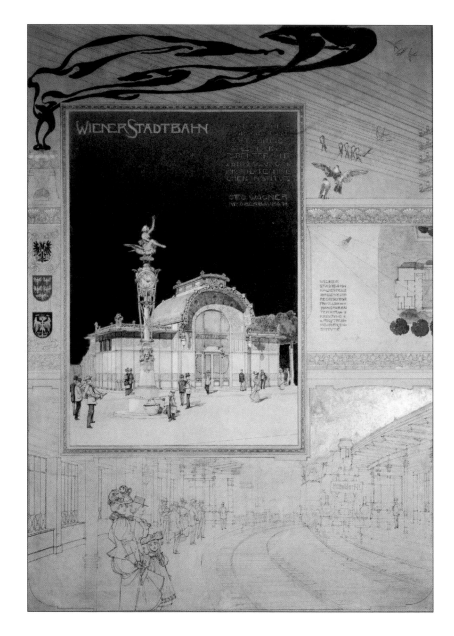

Plate 18

THE TWO GRACES

By Paul Ranson, 1895. Galerie Daniel Malingue, Paris, France.

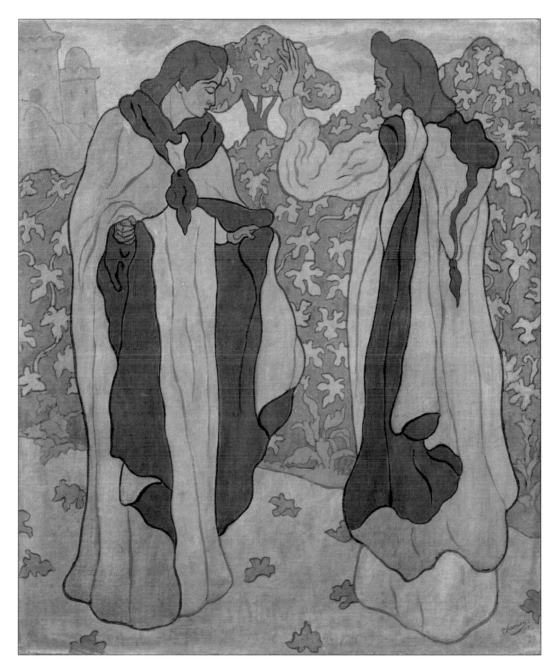

Plate *19*

VASE

Rockwood pottery vase, clay, by Artus van Briggle, 1896.
Museum of Fine Arts, Houston, Texas, USA.

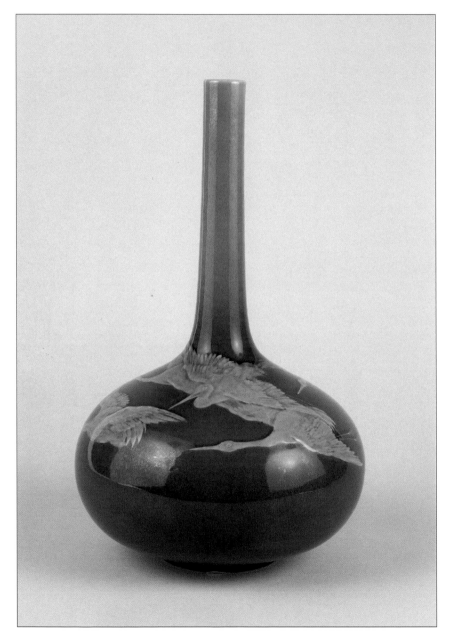

SIDE CHAIR

Plate 20

One of a pair made for Miss Cranston's Argyle Street Tearooms, Glasgow.
Oak, by Charles Rennie Mackintosh, 1896. Private Collection.

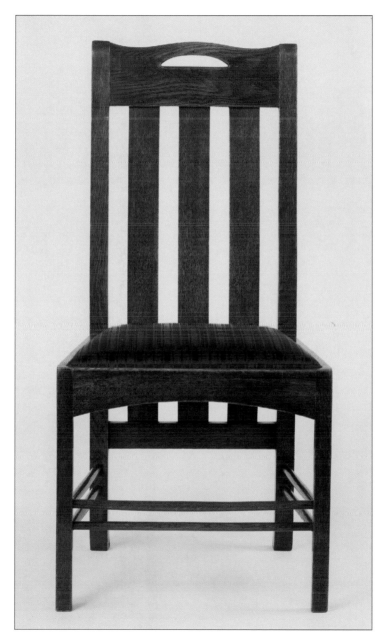

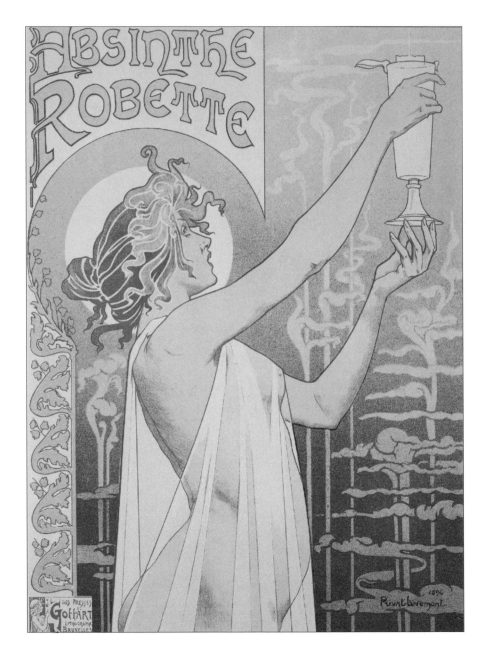

Colour litho, by Alphons Maria Mucha, 1896. The Mucha Trust.

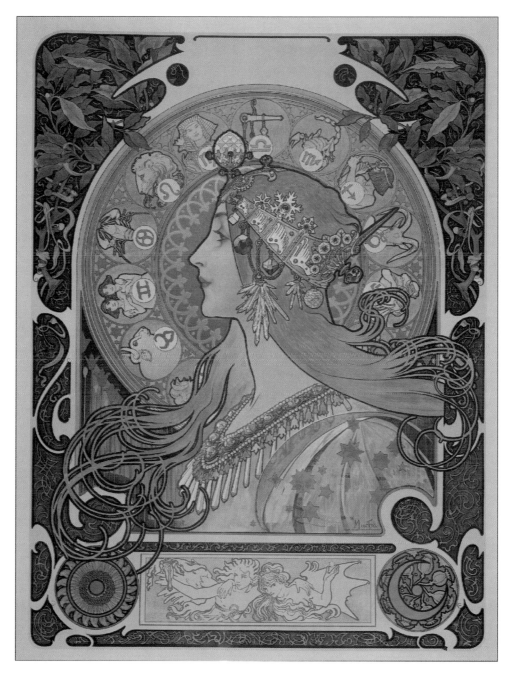

Plate 23 THE LOVE POTION

The month of May, for a magic calendar, published in 'Art Nouveau Review'.
Colour litho, by Manuel Orazi, 1896. Private collection/ Archives Charmet.

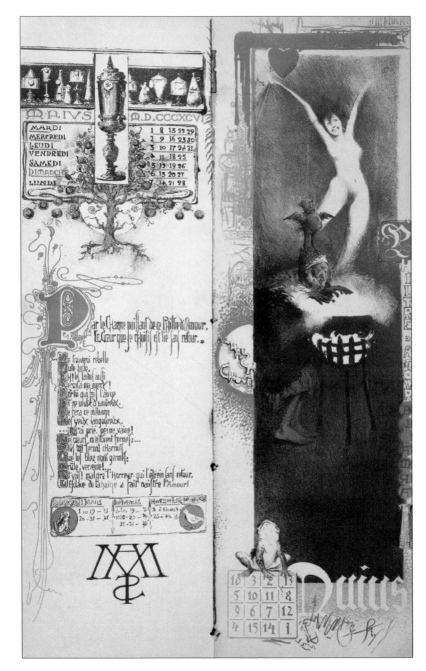

The month of August, for a magic calendar published in 'Art Nouveau Review'.
Colour litho, by Manuel Orazi, 1896. Private collection/ Archives Charmet.

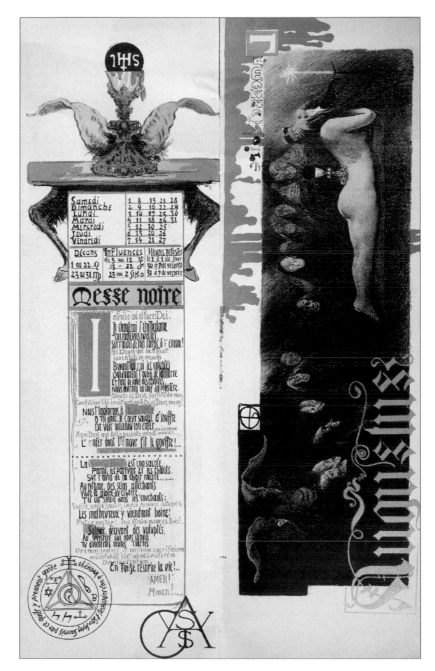

Plate 25 # THE WITCHES' SABBATH

The month of January, for a magic calendar published in 'Art Nouveau Review'.
Colour litho, by Manuel Orazi, 1896. Private collection/ Archives Charmet.

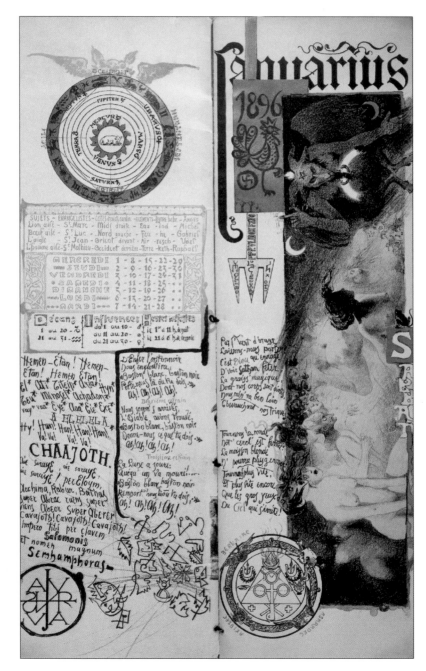

A competition for the best poster advertising the French cleaning agent
Colour litho, by various artists, French school, 1896. Private collection/ Archives Charmet.

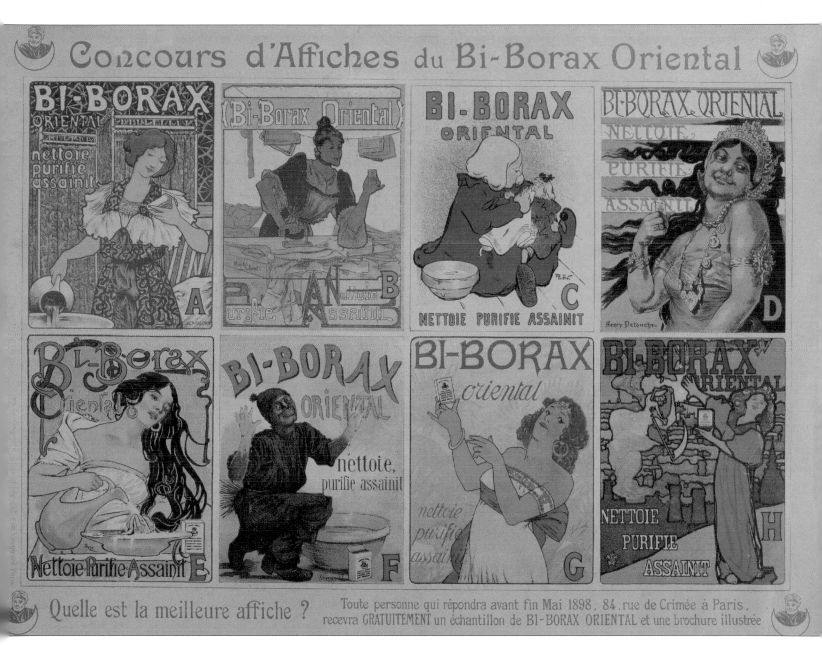

Plate 27

EXTERIOR, GLASGOW SCHOOL OF ART, GLASGOW, SCOTLAND

By Charles Rennie Mackintosh, 1897-99.

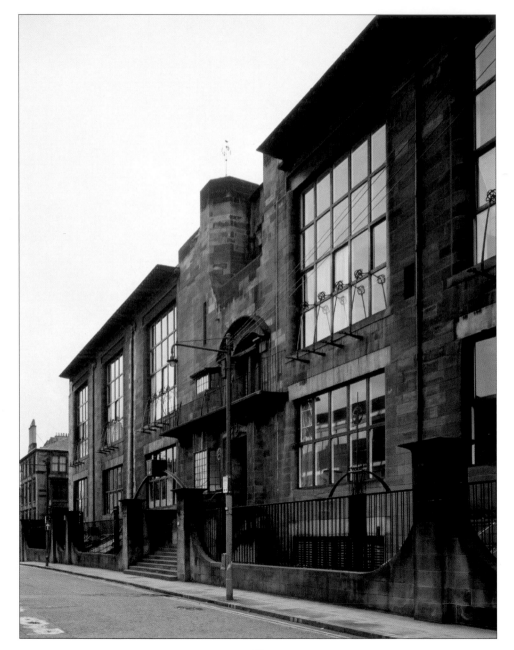

Plate 28

THE GOLDEN AGE

Oil on canvas, by James Vaszary, 1897-98. Magyar Nemzetri Galeria, Budapest, Hungary.

Plate 29

THE ARTS: DANCE

Colour litho, by Alphons Maria Mucha, 1898. The Mucha Trust.

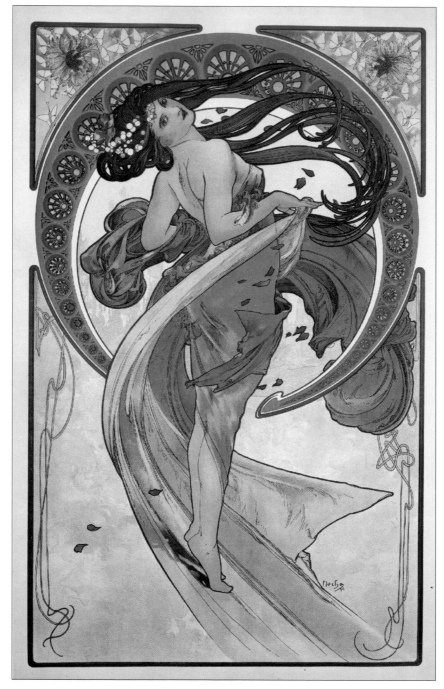

By Victor Horta, 1898-1901.

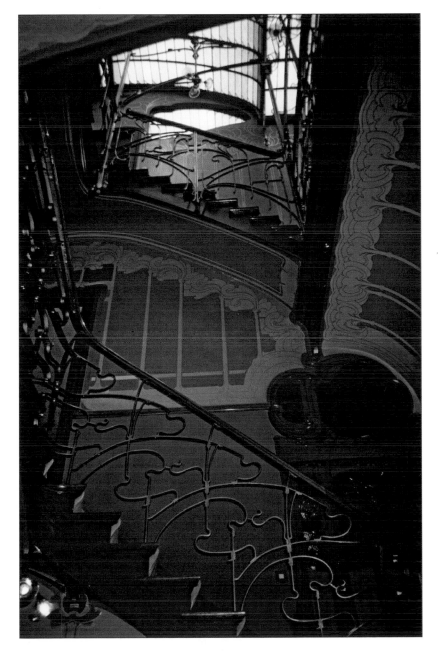

Plate 31 POSTER ADVERTISING 'COLLECTION DU CHAT NOIR'

Poster for the exhibition of the 'Collection du Chat Noir' cabaret at the hotel Drouot, Paris. Colour litho, by Theophile Alexandre Steinlen, 1898. Bibliotheque des Arts Decoratifs, Paris, France.

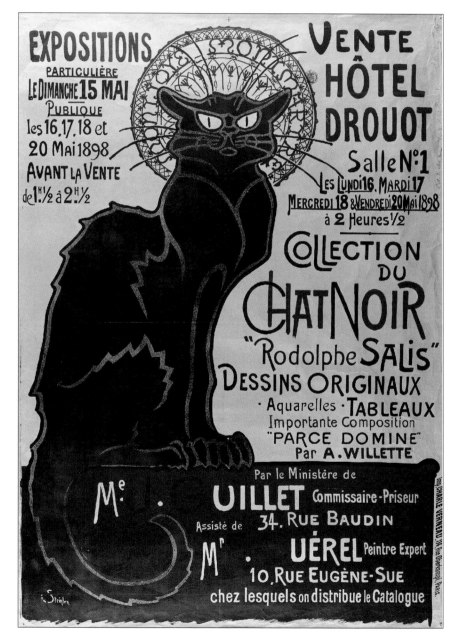

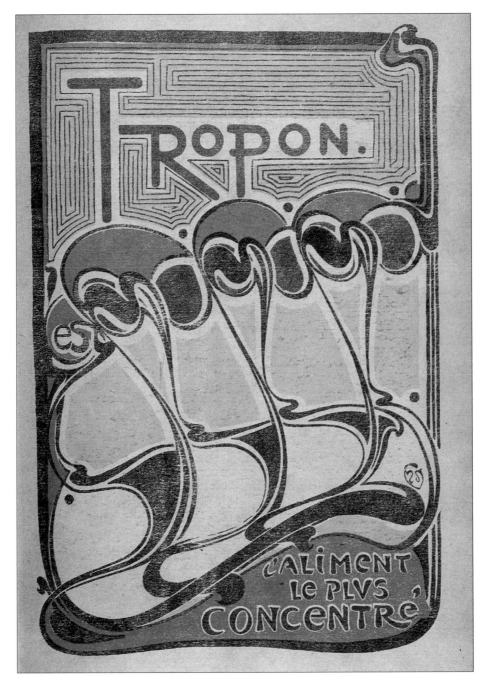

Plate 33

WINDOW OF MAJOLIKA HAUS, VIENNA, AUSTRIA

By Otto Wagner, 1898. Photograph © AISA

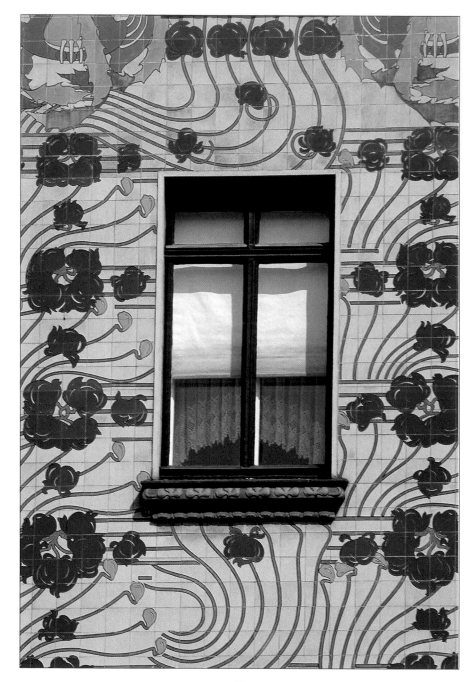

By Joseph Maria Olbrich, 1898.

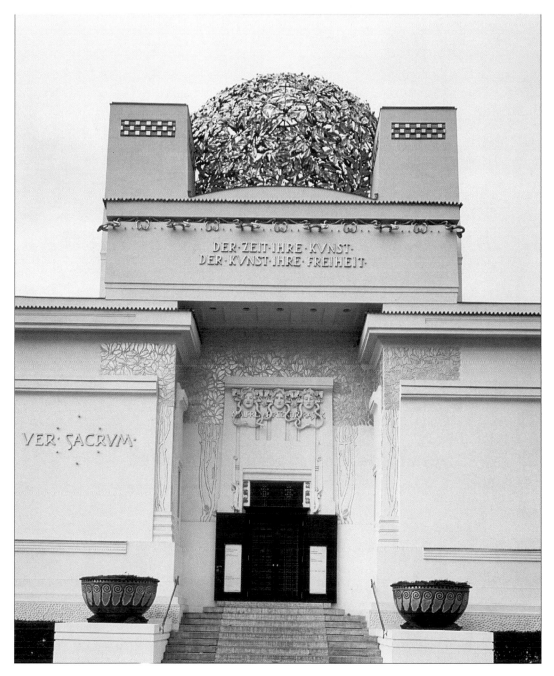

Plate 35

CEILING DETAIL IN HORTA HOUSE, RUE AMERICAINE, BRUSSELS, BELGIUM

By Victor Horta, 1898-1901.

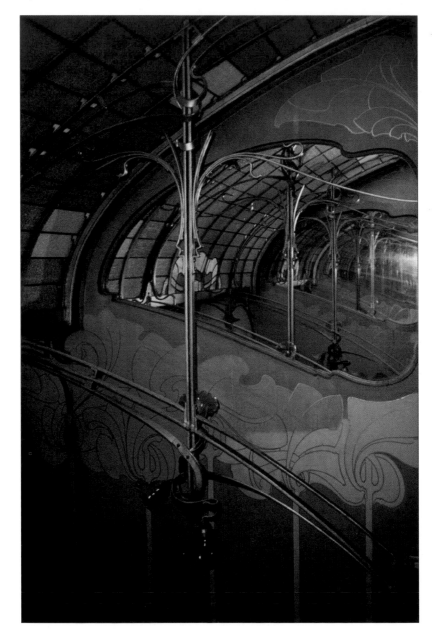

Textile, by Charles Francis Annersley, c. 1899. Private collection.
Photograph @ Bonhams, London, UK.

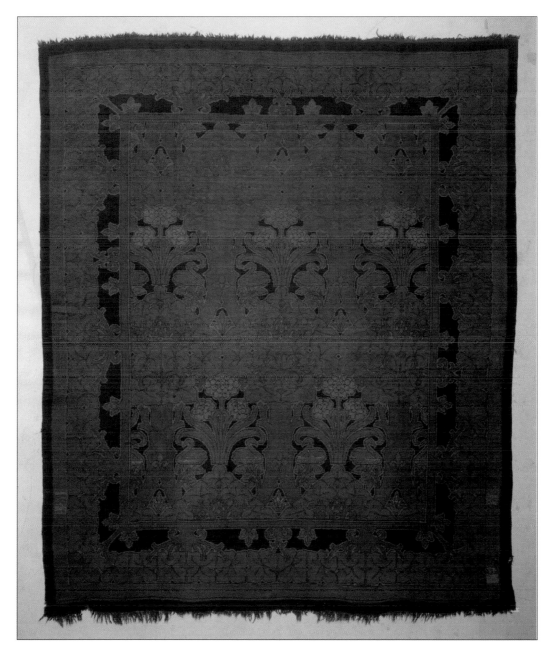

Plate 37

ELVES AND FAIRY PAINTERS

From 'The Snowman'. Watercolour on paper, by Walter Crane, 1899. Victoria and Albert Museum, London, UK/ The Stapleton collection.

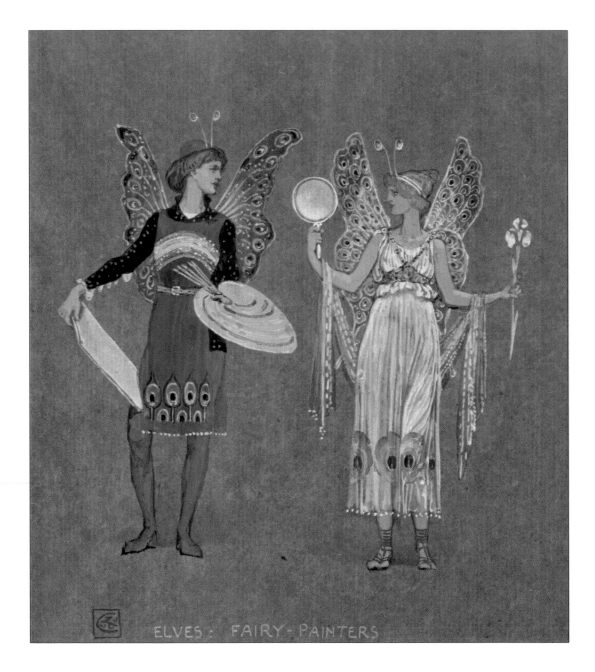

From a table centre piece, by Agathon Leonard Sevres,
1900. Hermitage, St Petersburg , Russia.

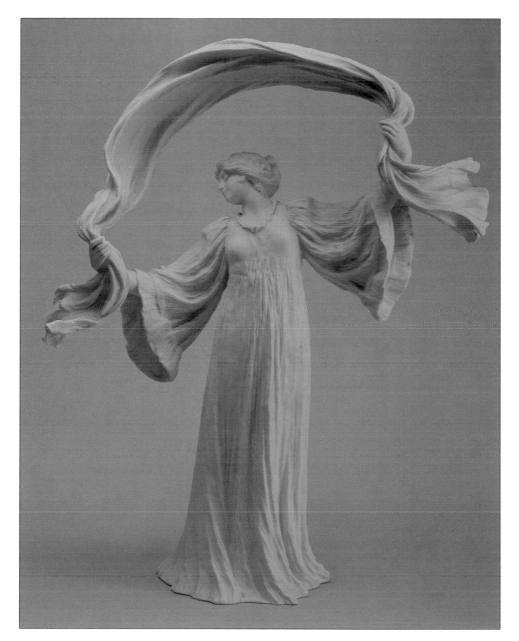

Plate 39

NENUPHAR SIDE TABLE

Wood, by Emile Galle, c.1900. Museé des Arts Decoratifs, Paris, France.

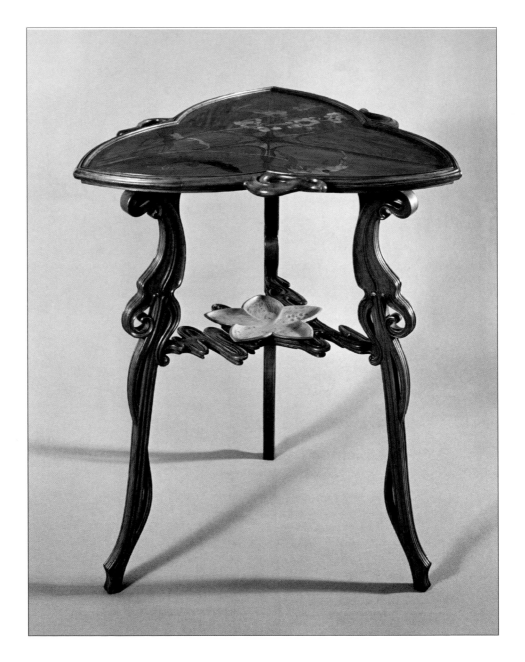

Plate 40

COMB

Gold, enamel and amethyst comb, by René Jules Lalique, c.1900.
Museu Calouste Gulbenkian, Lisbon, Portgual.

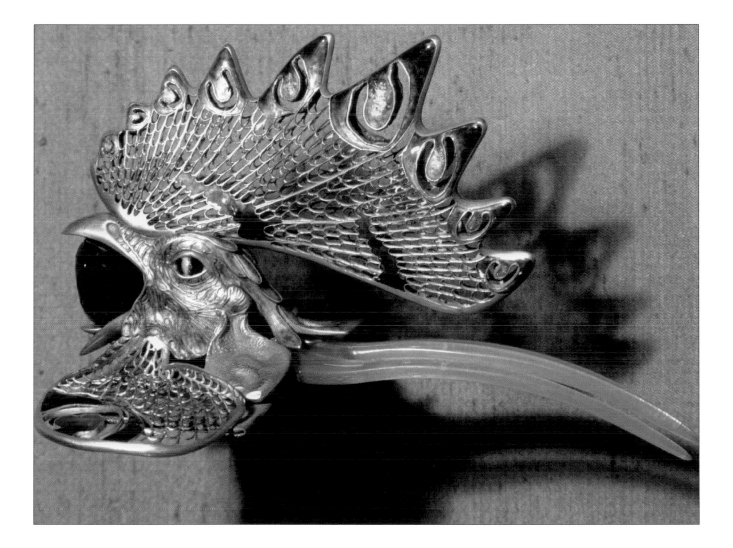

Plate 41

THE OFFERING

Oil on canvas, by Wilhelm List, c.1900. Musée des Beaux-Arts, Quimper, France.

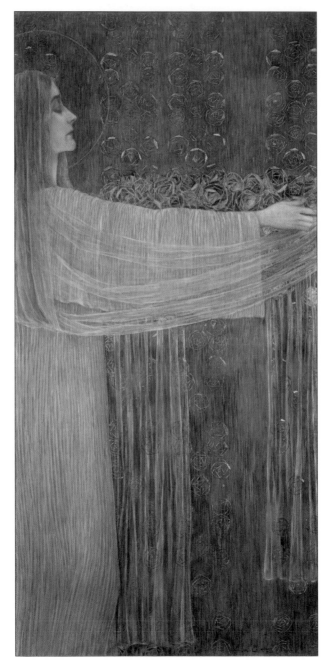

Oil painted gesso on hessian and scrim, by Margaret MacDonald Mackintosh, 1900. Art Gallery and Museum, Kelvingrove, Glasgow, Scotland. © Glasgow City Council (Museums)

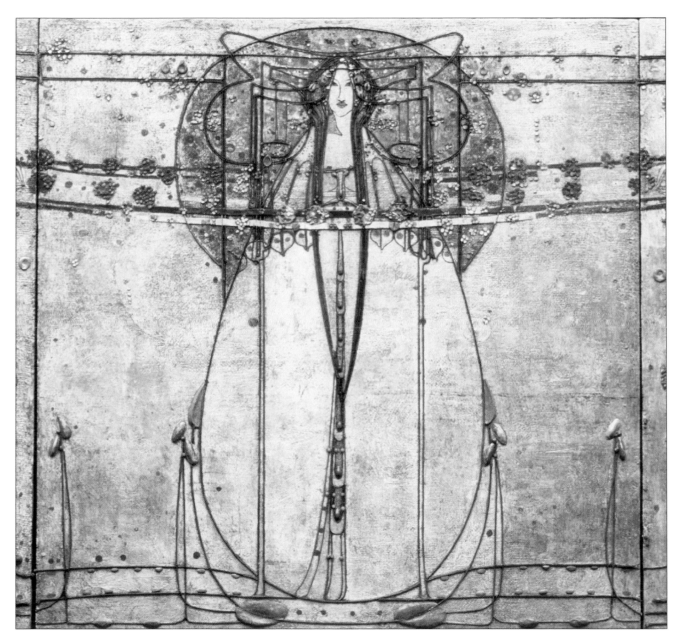

Plate 43

PANEL DESIGNS

Plate III from 'Modern Ornament' published by Decorative Art Journal Company Ltd. Colour litho, by H. Summerfield Rogerson, c.1900. Private collection/ The Stapleton collection.

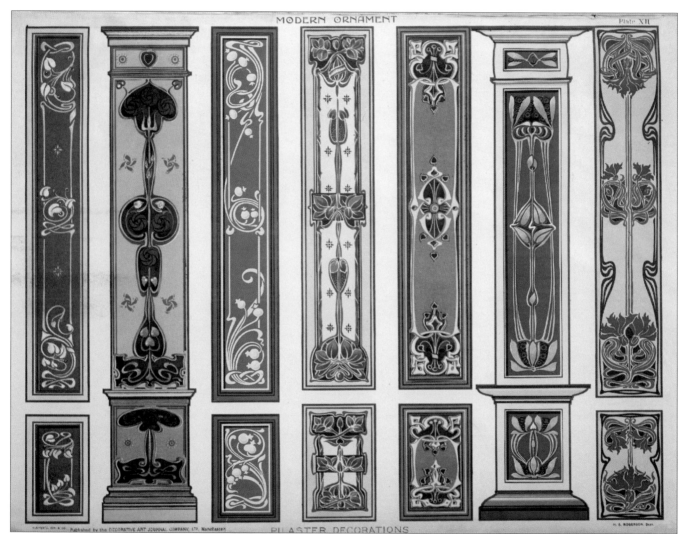

Plate XII from 'Modern Ornament' published by Decorative Art Journal Company Ltd. Colour litho, by H. Summerfield Rogerson, c.1900. Private collection/ The Stapleton collection.

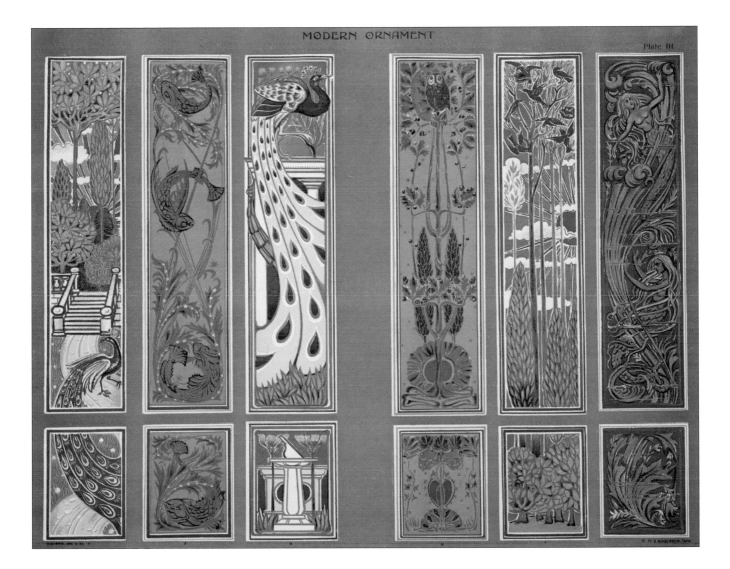

Plate 45

WOMAN'S CLOAK

Produced by Liberty, c. 1900-05. Photograph ©
Cheltenham Art Gallery & Museums, Gloucestershire, UK

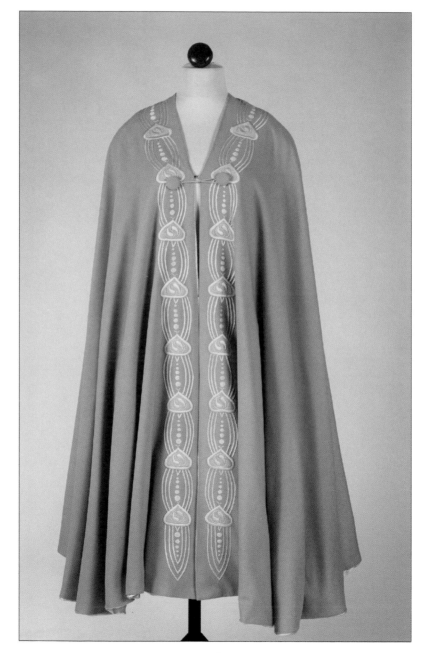

Plate 46

STUDY FOR ARTIST'S HOME

Pencil, pen and ink, watercolour and gouache on paper,
by Emil Hoppe, 1900. Private collection.

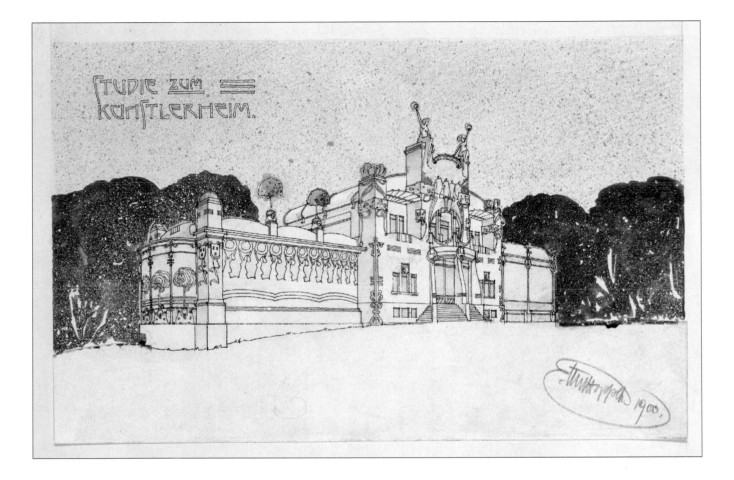

Plate 47

IGUANA

Ceramic, by Antoni Gaudi, c.1900-04. Parc Guell, Barcelona, Spain.

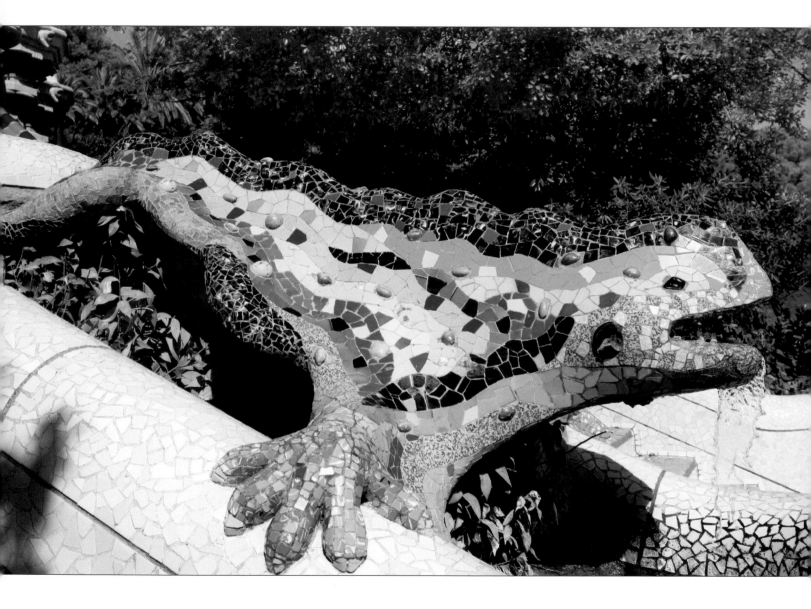

Plate 48

ARMCHAIR

Beech, stained mahogany and aluminium, by Josef Hoffmann,
c.1901. Private collection.

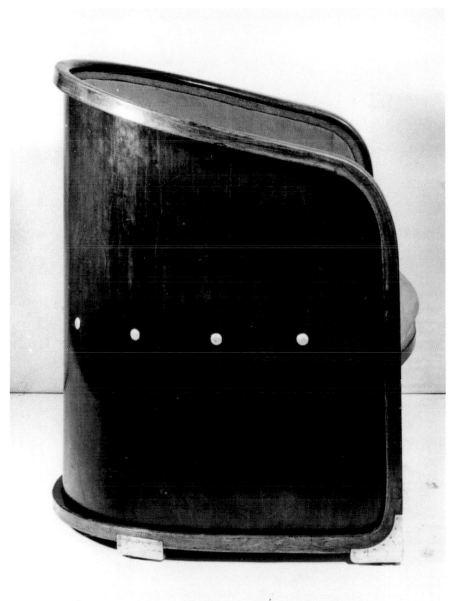

Plate 49

JUDITH

Oil on canvas, by Gustav Klimt, 1901. Österreichische Galerie Belvedere, Vienna, Austria.

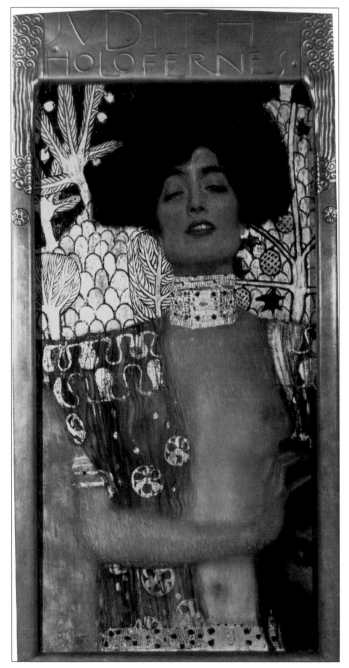

Plate 50

SARAH BERNHARDT

Colour litho, by Paul Berthon, 1901. Royal Albert Memorial Museum,
Exeter, Devon.

Plate 51

ENTRANCE

*Entrance to the apartments at 29 Avenue Rapp, Paris,
France, by Jules Lavirotte, 1901.*

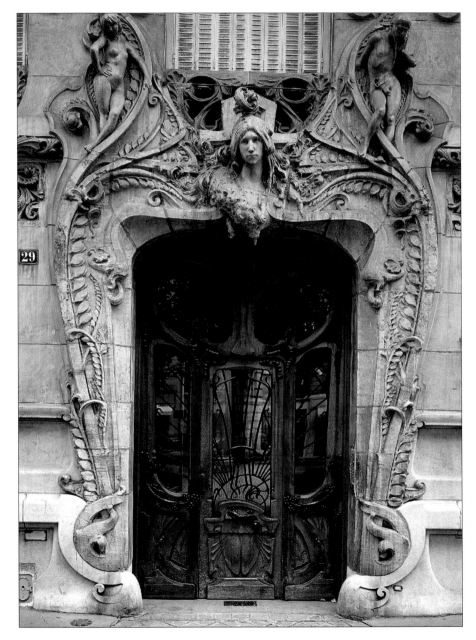

CHAIR AND TABLE
Plate 52

Wood, parchment, copper and pewter, by Carlo Bugatti, 1902.
The Israel Museum, Jerusalem, Israel.

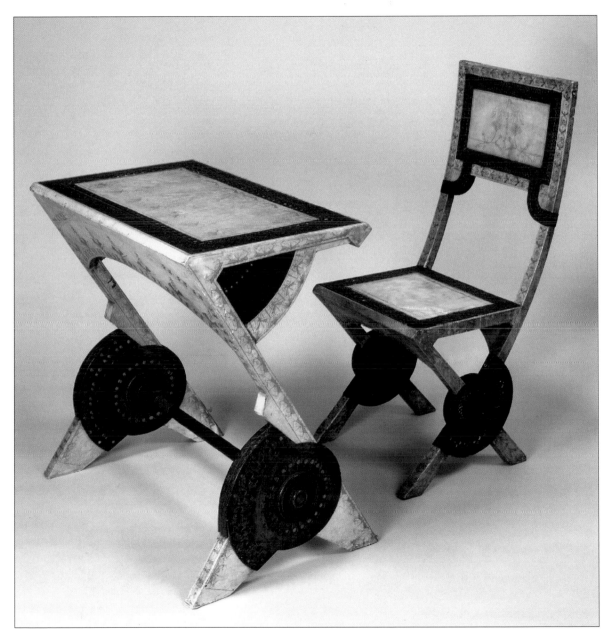

Plate 53

LA MAISON MODERNE

Poster by Manuel Orazi, c.1902. Musée des Arts Decoratifs, Paris, France.

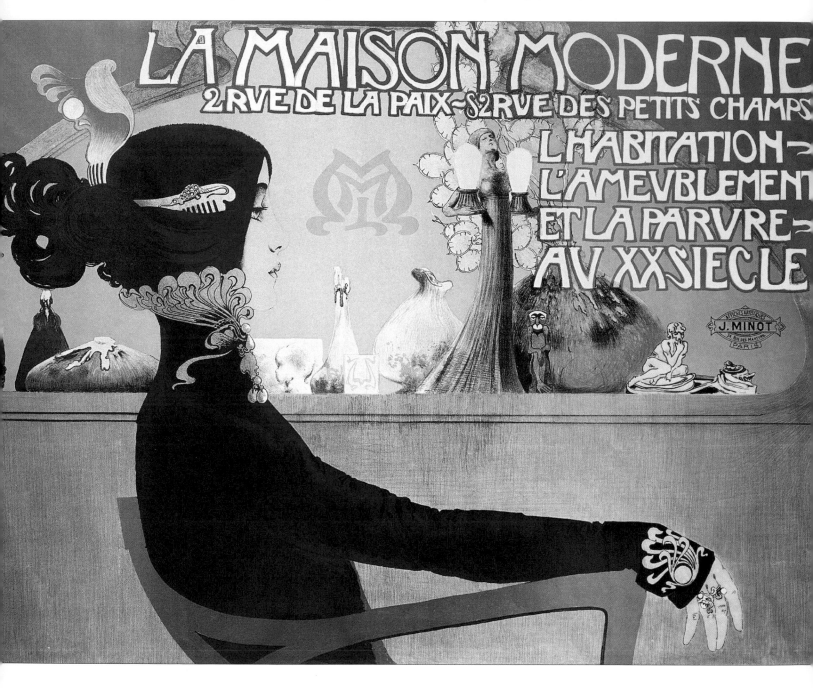

Oil on canvas, by Gustav Klimt, 1902. Wien Museum Karlsplatz, Vienna, Austria.

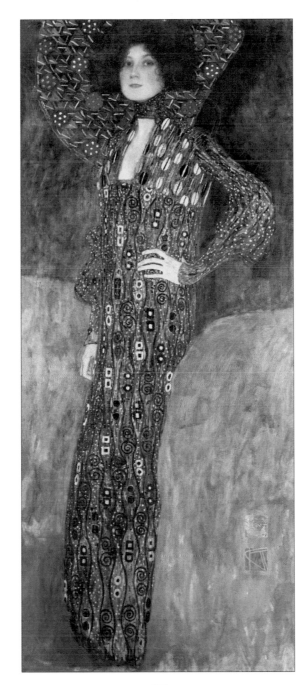

Plate 55

DESIGN FOR A MUSIC ROOM

With panels by Margaret Macdonald Mackintosh.
Colour litho, by Charles Rennie Mackintosh, c. 1902.
Private collection/ The Stapleton Collection.

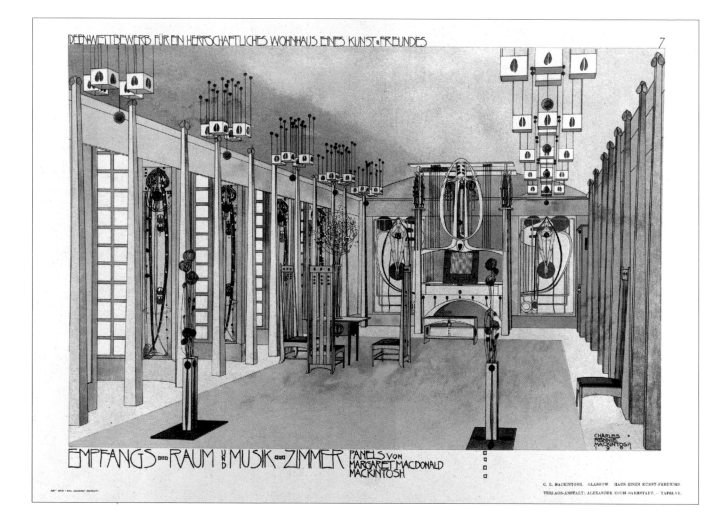

By, Leopald Bauer, Adolf Bohn, Josef Hoffmann, Gustav Klimt, Friedrich Konig,
Richard Kuksch, Kolomon Moser, Alfred Roller and Ernst Stohr. c. 1902.

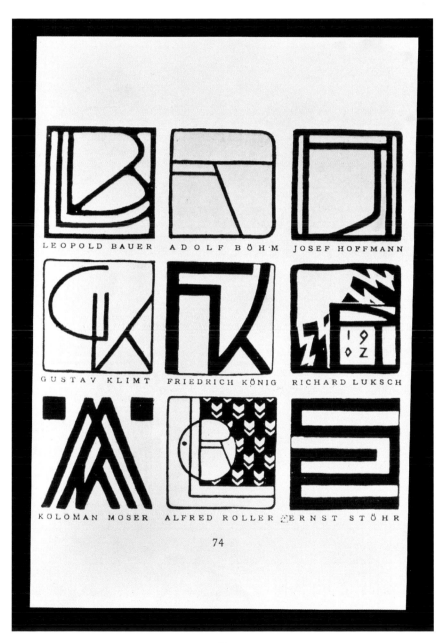

69

Plate 57

CABINET

Made for 14 Kingsborough Gardens, Glasgow. Painted oak,
by Charles Rennie Mackintosh, 1902. Private collection/ © The Fine Art Society, London, UK.

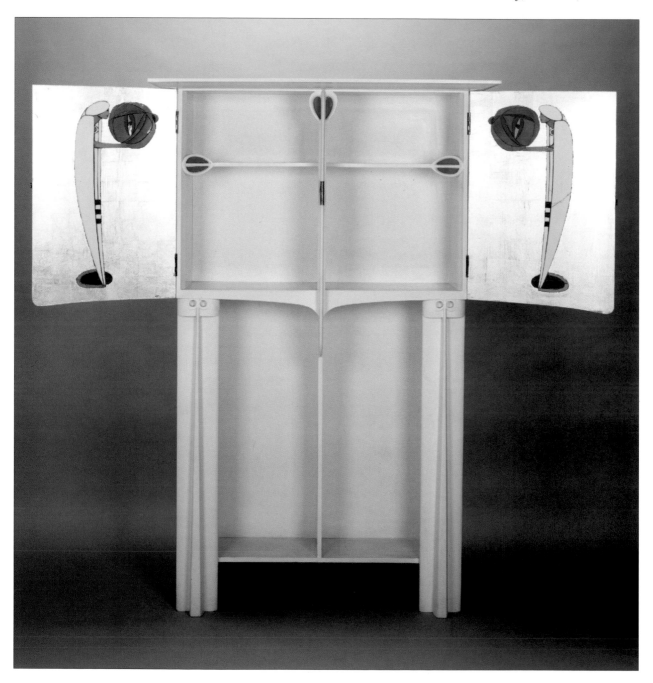

Gilded bronze and glass, by Louis Majorelle and Daum Brothers,
1902-04. Musée d'Orsay, Paris, France.

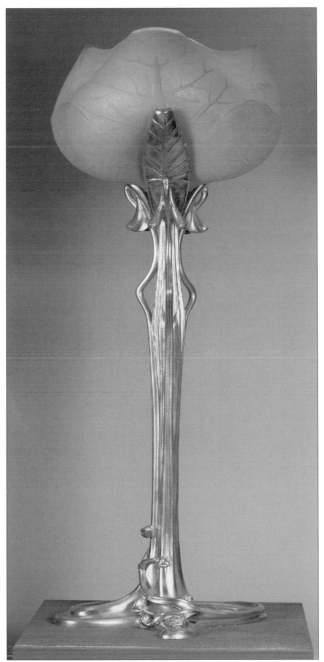

Plate 59

'ART NOUVEAU' ALPHABET

Colour litho, by E. Mulier, 1903. Bibliotheque Nationale, Paris, France/ Archives Charmet.

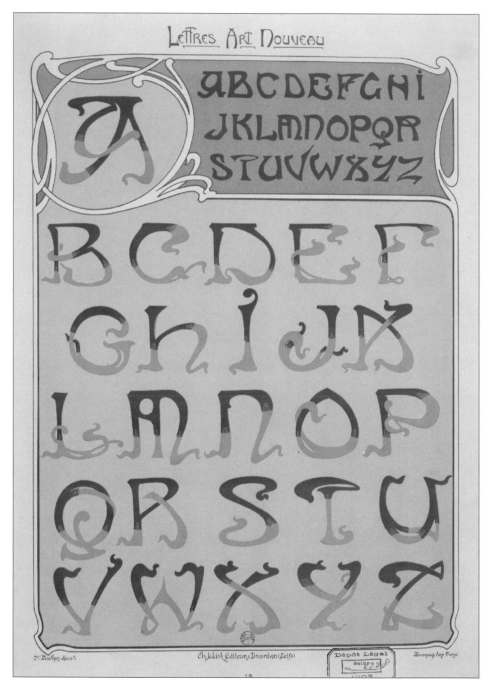

Colour litho, by E. Mulier, 1903. Bibliotheque National, Paris, France/ Archives Charmet.

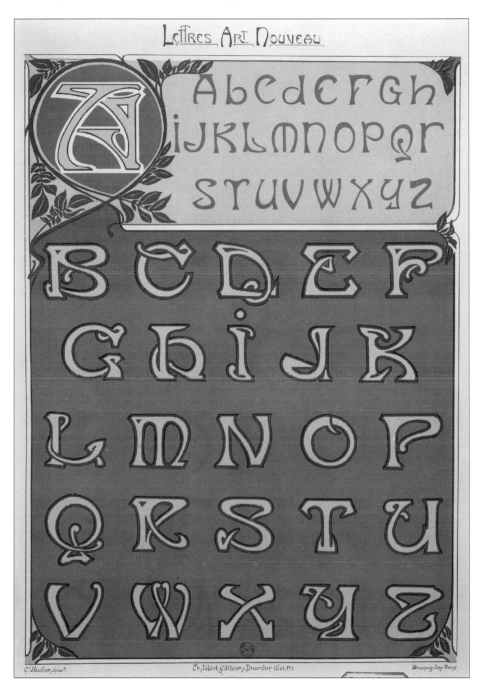

Plate 61

St Leopold's Church of the Steinhof Asylum, Vienna, Austria

Designed by Otto Wagner, decorated by Kolo Moser, 1903-07.

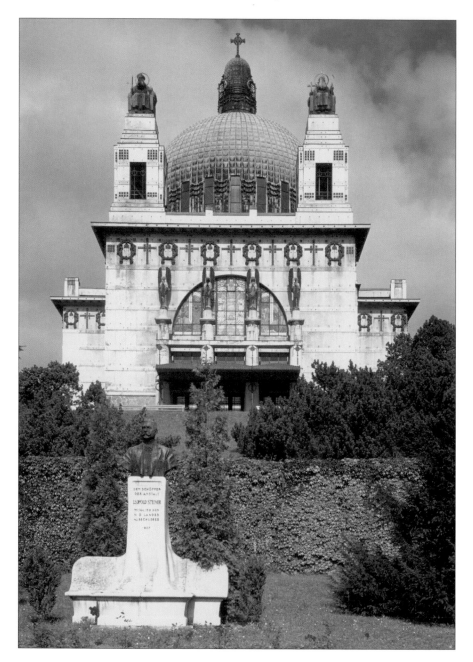

Wooden Sofa from the dining room at Casa Battlo, designed by Antoni Gaudi,
1904-06. Museo Gaudi, Barcelona, Spain.

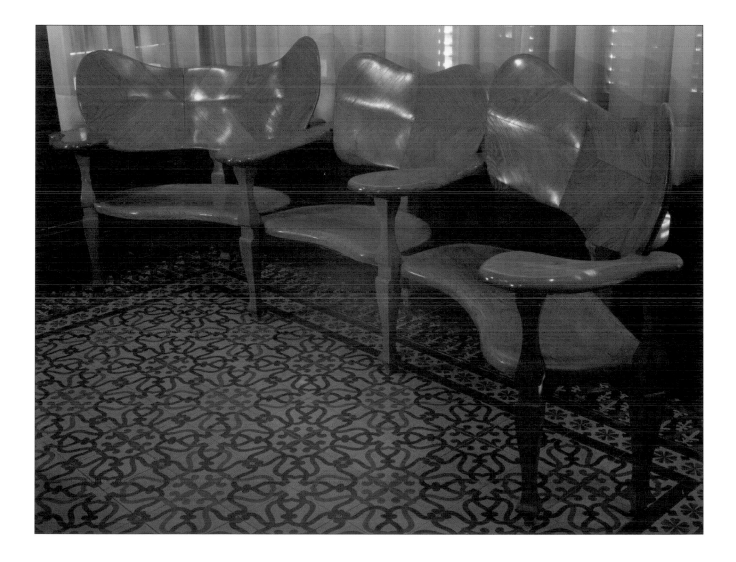

Plate 63

STUDY FOR OLBRICH'S HOUSE, DARMSTADT

From Architektur von Olbrich
Colour litho, by Joseph Maria Olbrich, c. 1904-14. Private collection.

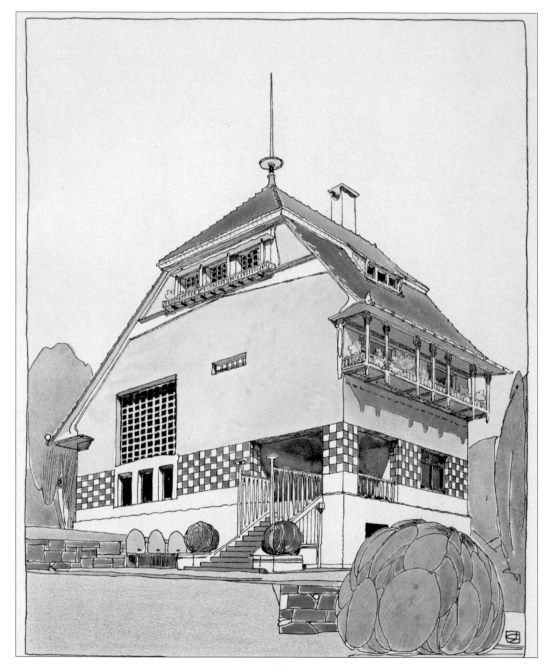

ONE OF A PAIR OF ARMCHAIRS FOR THE BLUE BEDROOM *Plate 64*

For the Blue Bedroom at Hous'Hill, Glasgow. Stained oak with mother of pearl inlay,
by Charles Rennie Mackintosh, 1905. Private collection.

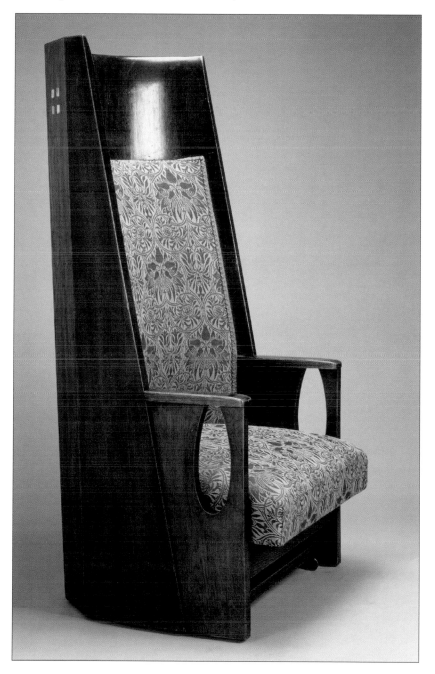

Plate 65

SITZMASCHINE (SITTING MACHINE)

Beech with plywood seat, back and sides, designed by Josef Hoffmann, c.1905. Private collection.

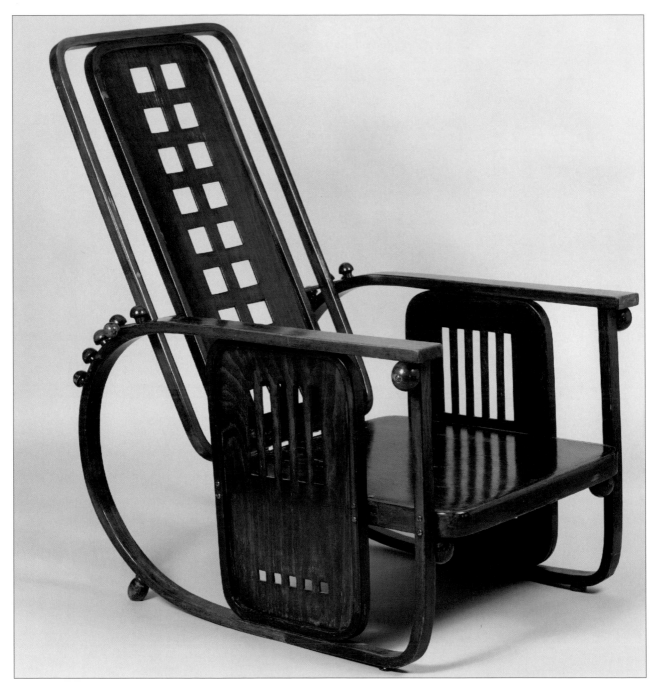

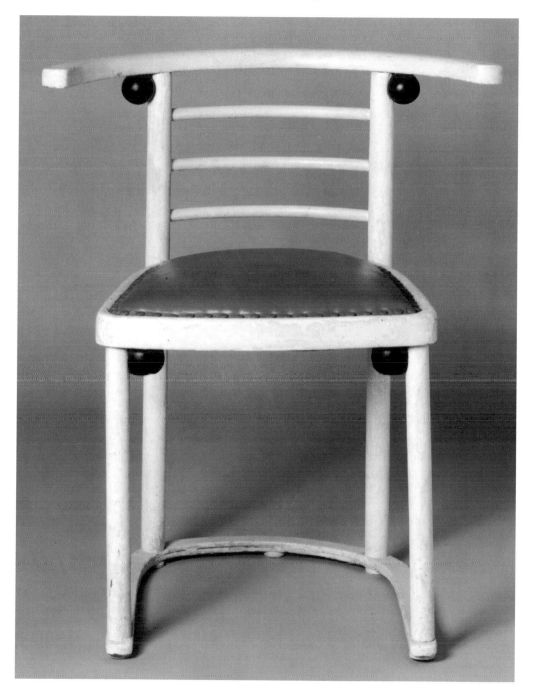

Laquered beech and leather, designed by Josef Hoffmann, 1905. Private collection.

Plate 67

SPRING

Oil on canvas, by Maximilian Lenz, c. 1905.
© National Museum and Gallery of Wales, Cardiff.

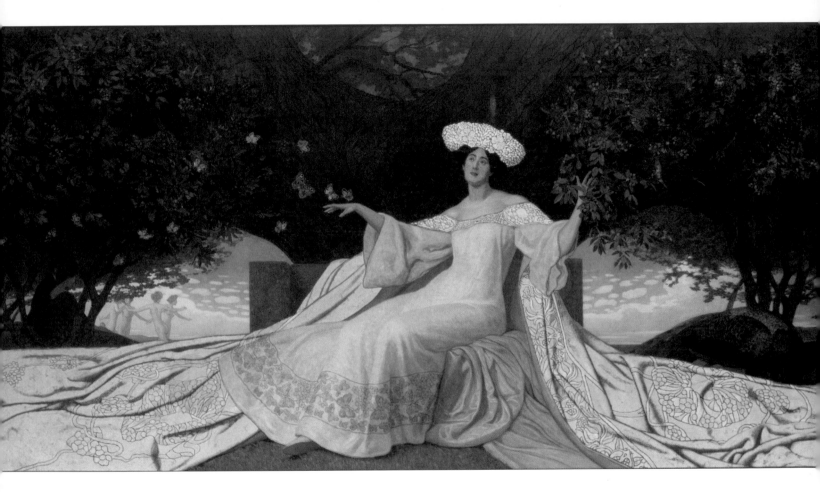

Tempera and watercolour, by Gustav Klimt, c.1905-09.
MAK Austrian Museum of Applied Arts, Vienna, Austria.

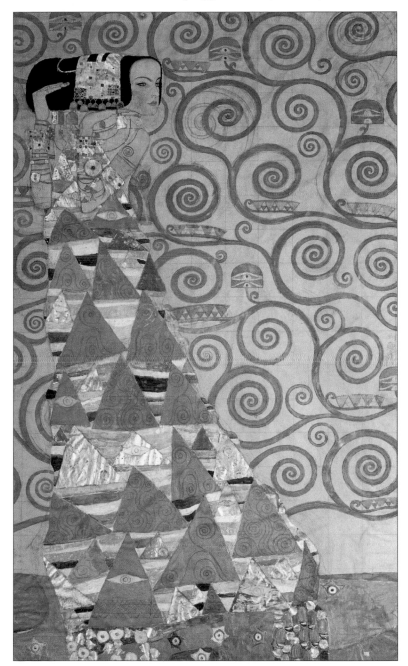

Plate 69

NENUPHAR BED

Wood and bronze, by Louis Majorelle, 1905-09. Musée d'Orsay, Paris, France.

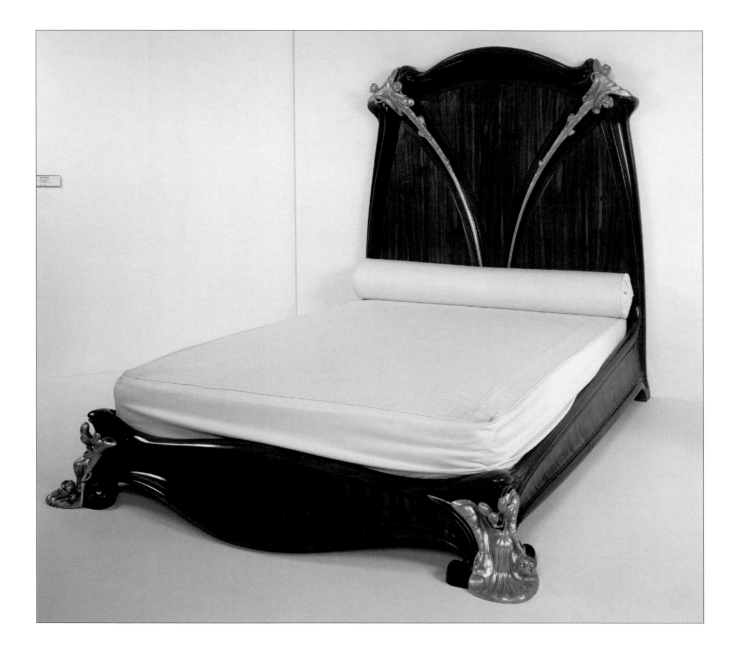

Beech, by Josef Hoffmann, c.1906. Private collection.

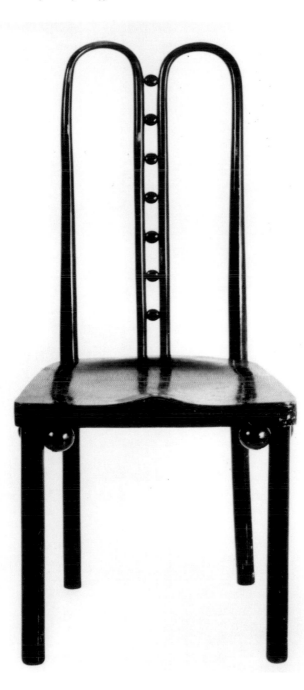

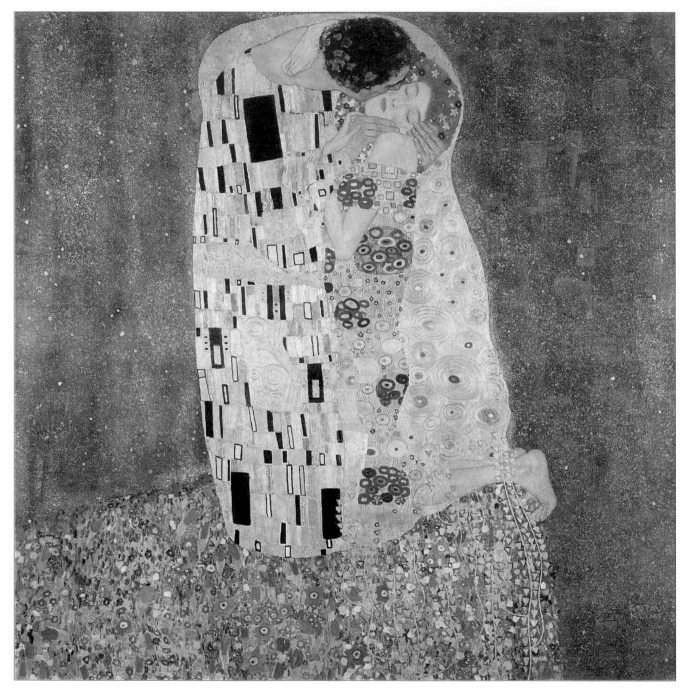

FIGURINE OF ISADORA DUNCAN

Plate 72

Glass with powder dyes, by A.Walter Nancy, 1908-14.
Mazovian Museum, Plock, Poland.

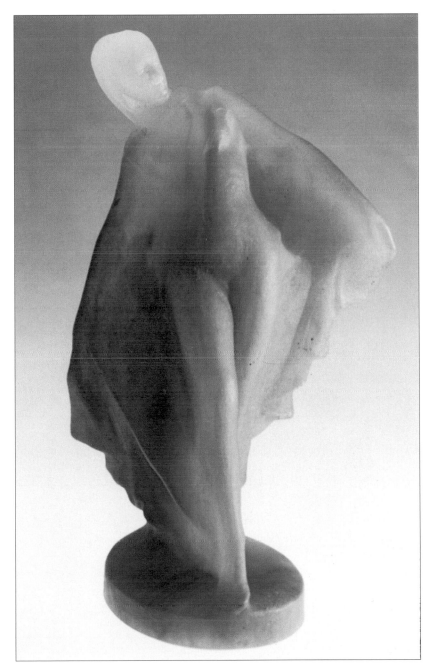

Plate 73 STATION DE METRO ANVERS

Anvers Station, Paris, France. Designed by Hector Guimard, 1909.

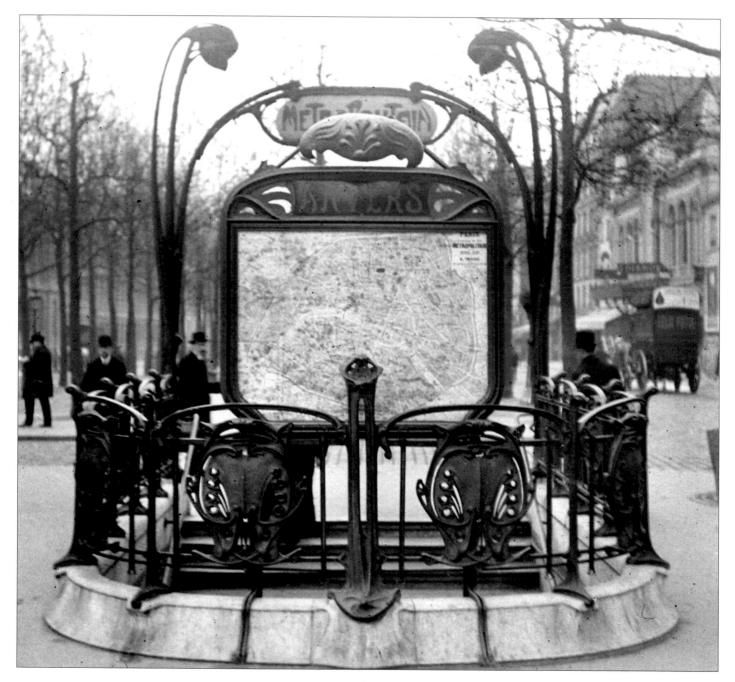

THE MYSTERIOUS GARDEN

Plate 74

Watercolour and ink over pencil on vellum laid on board, by Margaret MacDonald Mackintosh, 1911.
© The Fine Art Society, London, UK.

Plate 75

ADELE BLOCH BAUER II

Oil on canvas, by Gustav Klimt, 1912. Private collection.

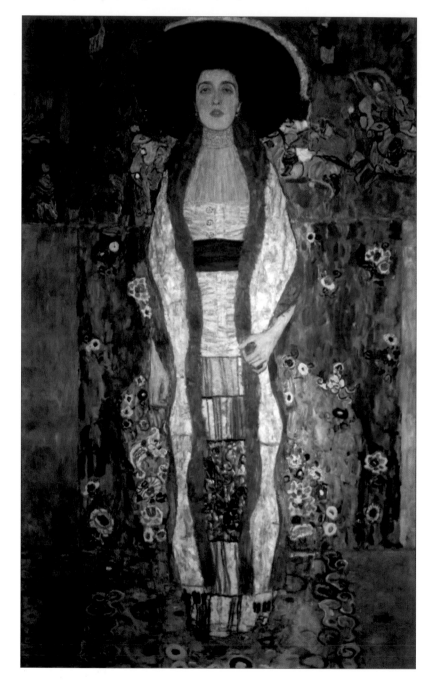

Oil and gold on canvas, by Vittorio Zecchin, 1912. Museo d'Arte Moderna, Venice, Italy.

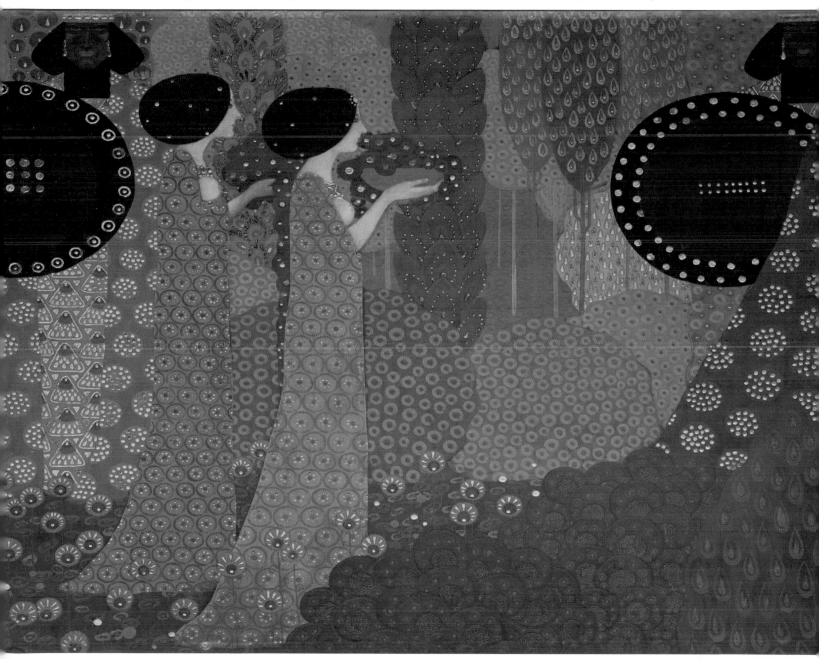

Plate 77

Au Clair de la Lune

Watercolour on paper, by Paul Poiret and George Lepape, 1913. Private collection.

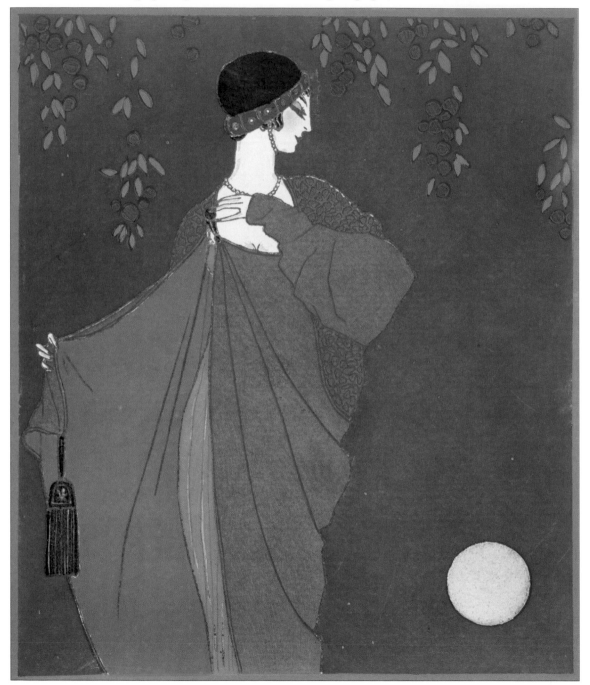

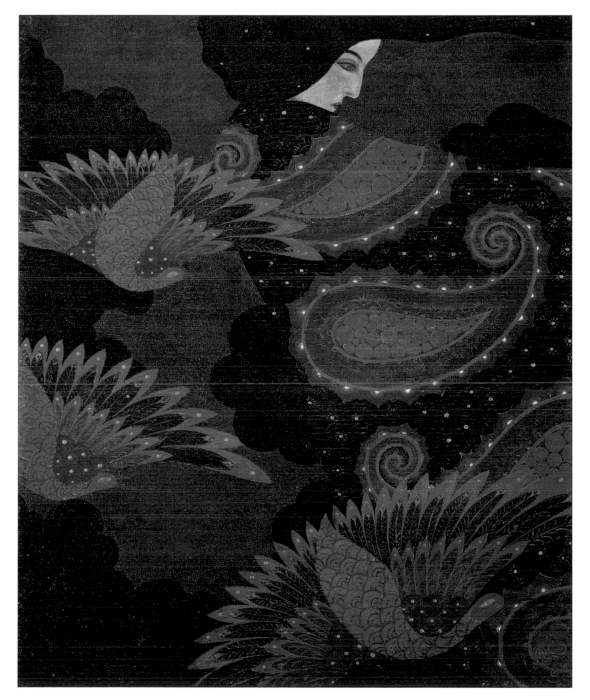

DOGESS IN BLACK

Gold and oil on canvas, by Vittorio Zecchin, 1913.

Plate 78

Plate 79 BUREAU AND CHAIRS

From Hermine Gallia's boudoir. White enamelled wood, glass and silk, designed by Josef Hoffmann, 1913. National Gallery of Victoria, Melbourne, Australia.

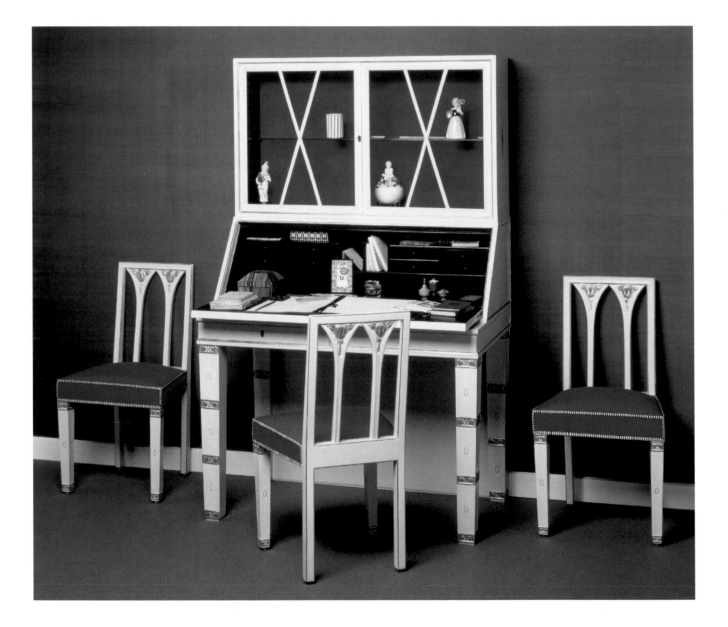

Plate 80

THE EMPEROR AND THE NIGHTINGALE

Illustration for 'The Nightingale', from 'Fairy Tales', by Hans Christian Andersen.
Engraving, by Harry Clarke, c.1914. Private collection.

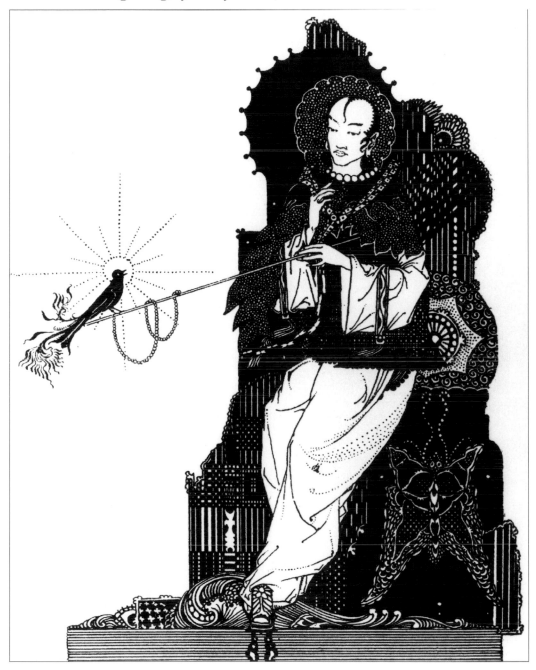

Plate 81 STAATLICHES BAUHAUS, DESSAU, GERMANY

By Walter Gropius, Typography by Herbert Bayer, 1925-26.

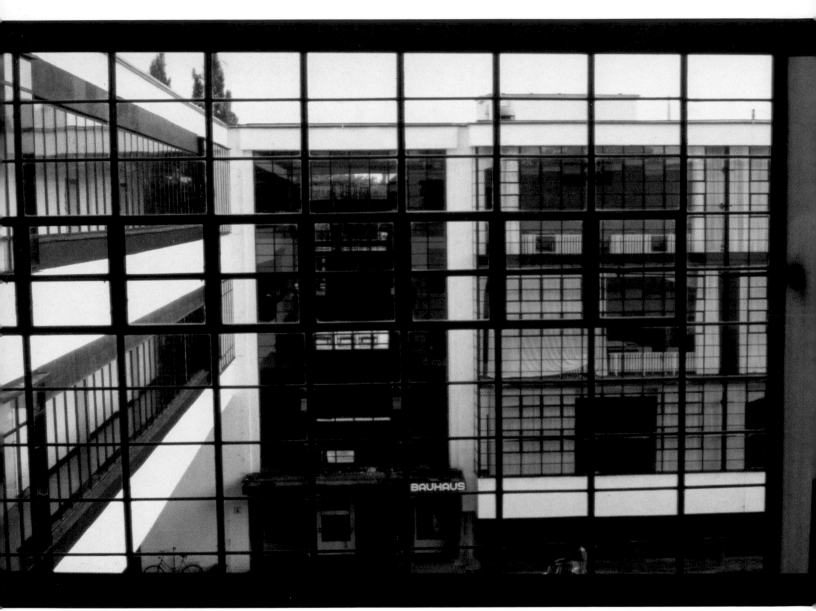

By Walter Gropius, 1925-26.

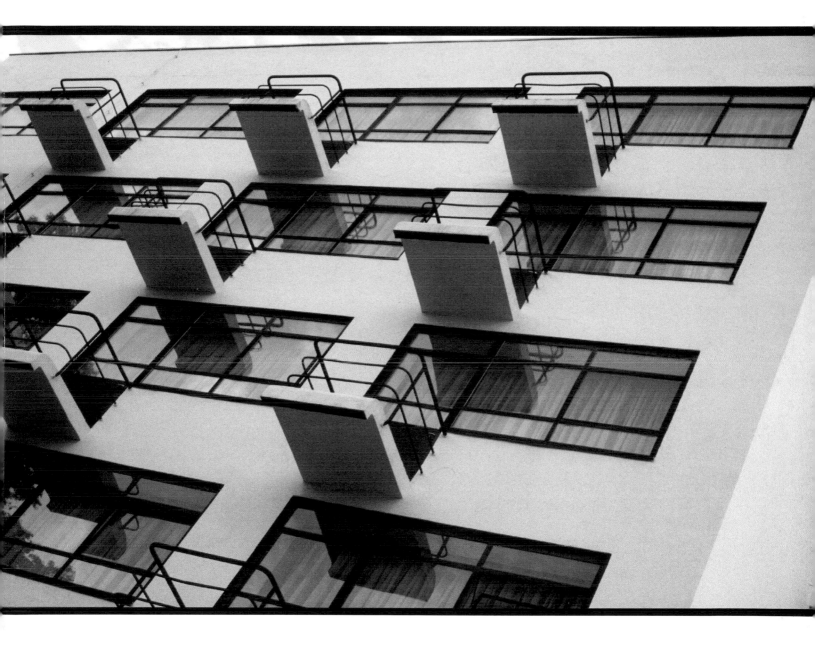

ALPHABETICAL INDEX